MARTÍ GUIXÉ

LIBRE DE CONTEXTE

MARTÍ GUIXÉ

LIBRE DE CONTEXTE
CONTEXT-FREE
KONTEXT-FREI

INCLUDING THE KITCHEN-BUILDINGS PROJECT

Textes / Contributions / Beiträge / Inga Knölke, Chantal Prod'Hom, Brigitte Rambaud, Octavi Rofes

mu.dac / Editeur / Editor / Herausgeber

Birkhäuser — Editions d'architecture / Publishers for Architecture / Verlag für Architektur _Basel • Boston • Berlin

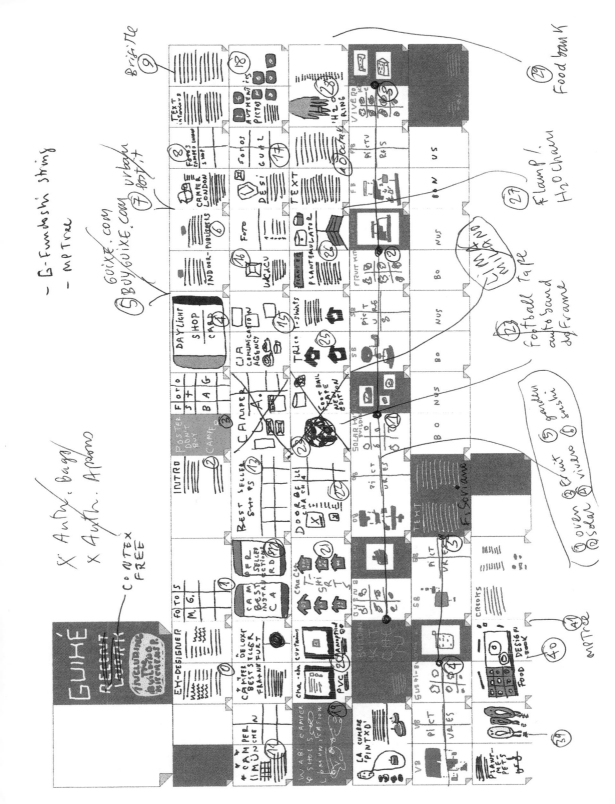

BERUF: EX-[DEIN BERUF]

Entgrenzung von Berufsdefinitionen

Das Konzept, das hier vorgestellt wird, ist das Antriebsmittel -EX-

Antriebsmittel: -Ex-

Durch die Hinzufügung des Titels Ex erhält der Berufstätige einen neuen Status.

Jeder Beruf ist von festgeschriebenen und von mündlichen Normativen in ethischer, politischer und sozialer Hinsicht beschränkt.
z.B.: Ein Philosoph kann nicht unbescholten an einer Fernsehtalkshow teilnehmen.
Ein Künstler verhält sich ungeschickt, wenn er kommerzill arbeitet. Einem Architekten sind aus ethischen Gründen bestimmte Vorhaben nicht erlaubt.

Der Titel -Ex- will Personen ermöglichen, außerhalb der den Beruf definierenden Eigenschaften zu arbeiten.

Ex- ist ein demokratischer Selbstbedienungstitel.

-Ex- ist ein demokratischer Selbstbedienungstitel. Jeder kann sich so nennen.
Im Zusammenhang mit einer Berufsbezeichnung wirkt der Titel -Ex- als Antriebskraft.
Im Zusammenhang mit einer Berufsbezeichnung steht der Titel -Ex- für die Öffnung des professionellen Status und infolgedessen auch für eine Veränderung des sozialen Status (das Konzept Status verschwimmt).

Funktionsweise
So nicht: 2 Fallbeispiele
Boris Becker ist heute Ex-Tennisspieler. Er arbeitet aber nicht als Ex-Tennisspieler, sondern als Trainer, Model, usw.. Dies bedeutet, das er sich in einem anderen Beruf begrenzt.
Klaus Bayer, Bauarbeiter, 34 J., stürzt bei der Arbeit in der Grünbergerstraße vom Gerüst. Danach ist er Ex-Bauarbeiter, der aber nicht als Ex-Bauarbeiter arbeitet.

Nach unserer Definition können die Beispielpersonen, weil sie nicht entscheiden als Ex-[Sein Beruf] zu arbeiten, nur als ehemalige + [Sein Beruf] bezeichnet werden.

Ex- designer me paraît être le terme le plus approprié pour désigner mon activité actuelle et définir de façon pertinente mon statut personnel. Ex- élément déterminant de mon statut personnel, brise avec le tabou qui règne aujourd'hui sur les institutions culturelles, qui ne s'intéressent qu'aux questions sociales.
On me demande souvent si je ne travaille plus. Je réponds que je travaille toujours comme ex-designer._Ex- Elément de mon statut personnel / Projet, 2001 / En collaboration avec Inga Knölke

Ex- designer seems to me to be the term which best defines what I do and how I do it, effectively defining my status. Ex- as a self-status element; this term breaks the current taboo of cultural institutions, solely interested as they are in social questions.
As I am often asked if I am no longer working, I respond that I am, but as an ex-designer. _Ex- / Self-status element / Project, 2001 / With Inga Knölke

Projektbeispiel: Martí Guixé
Interview mit Inga Knölke, 28.8.2002

F: Warum hast du beschlossen, Ex-Designer zu werden?
A: 2001 habe ich beschlossen als Ex-Designer zu arbeiten, weil der Beruf Ex-Designer keine Begrenzungen hat.
F: Kannst du die Aufhebung der Begrenzung und den Freiheitsgewinn näher erläutern?
A: Die Arbeitsaufgaben sind unterschiedlicher und umfassender geworden. Insgesamt ist es interessanter, spannender und abwechslungsreicher.
F : Wie ist das Feedback?
A : Die ehemaligen Berufskollegen reagieren skeptisch, aber die Kunden und die soziale Umgebung finden den Beruf sehr spannend.
Wenn die Leute die Berufsbezeichnung Ex-Designer sehen, fragen sie mich, „arbeiten Sie nicht mehr"? Ich antworte dann: „Doch, als Ex-Designer".
F : Und wie ist die ökonomische Situation?
A :Grenzenlos.
F : Wie sieht der Alltag aus?
A : Ich bestimme meine Arbeitszeit selbst und bin ortsunabhängig, habe kein Büro mehr, und muß mich nicht zwingend irgendwo aufhalten, da die regionalen Vertretungen hinfällig geworden sind. Die Präsentationen meiner Projekte sind unabhängig und frei von Verkleidung (DesignerLook).
F : Vielen Dank für das Gespräch.

WENN DIE LEUTE DIE BERUFSBEZEICHNUNG EX-DESIGNER SEHEN, FRAGEN SIE MICH, „ARBEITEN SIE NICHT MEHR"? ICH ANTWORTE DANN: „DOCH, ALS EX-DESIGNER"

MARTÍ GUIXÉ
33,3% à Barcelone, 33,3% à Berlin; les autres 33,3%: ailleurs.

MARTÍ GUIXÉ
33.3% in Barcelona, 33.3% in Berlin and the other 33.3% elsewhere.

MARTÍ GUIXÉ
33,3 % in Barcelona, 33,3 % in Berlin und die übrigen 33,3 % andernorts.

MARTÍ GUIXÉ OU LES JEUX D'USAGES

What u c is not (necessarily) what u get

Pour les non-initiés aux échanges par *sms*, il faut énoncer verbalement cette phrase pour la capter. Il faut changer de code, prolonger le visuel par le sonore. Le message évoque à son tour les pièges tendus à notre capacité perceptive car il retourne comme gant le slogan publicitaire bien connu: *what you see is what you get*.

Prenons d'ailleurs l'exemple des gants dont Guixé a réalisé, en 1999, une paire insolite pour la firme Camper. Dans cet exemple, l'évidence de la symétrie en miroir de nos deux mains est écartée au profit d'un regard porté sur l'usage: un des gants respecte la traditionnelle indépendance de nos cinq doigts alors que l'autre se réfère au moufle et ne laisse libre que le pouce. Les deux options, rassemblées en une seule paire, associent deux contraintes généralement incompatibles: la finesse de la préhension et le maintien de la chaleur corporelle. Il semble clair que l'asymétrie n'est pas motivée par un effet de style: les deux usages sont pertinents et même nécessaires. Loin des modes et des

MARTÍ GUIXÉ OR THE PLAY ON USES

What u c is not (necessarily) what u get

For the uninitiated in text-messaging matters, you have to say the above phrase out loud in order to get it. You have to change code, extend the visual through the sound. In its turn the message evokes the traps set for our perceptive capacity, since it turns the well-known advertising slogan *What you see is what you get* inside out.

Let's take by way of example the unusual pair of gloves that Guixé made for the firm Camper in 1999. In this example, evidence of the mirror symmetry of our two hands is brushed aside in favour of a look at the use of gloves: one of the gloves respects the traditional independence of the five digits whereas the other, with a nod to the mitten, leaves only the thumb free. The two options gathered together in a single pair link two generally incompatible constraints: sensitivity of grip and retention of body heat. It seems clear that the asymmetry is not motivated by a desire for stylistic effect: both uses are pertinent, even necessary. Far from fashion and purely formal preoccupations,

MARTÍ GUIXÉ ODER DIE GEBRAUCHSSPIELE

What u c is not (necessarily) what u get

Für die nicht in den Austausch von SMS Eingeweihten muss man diesen Satz in Worte fassen, um ihn zu begreifen. Man muss den Code ändern, das Sichtbare durch das Hörbare ergänzen. Die Botschaft selbst erinnert an die Versuchungen, die unserer Wahrnehmungsfähigkeit gestellt werden, da sie den bekannten Werbeslogan völlig umkehrt: *What you see is what you get*. Nehmen wir etwa das ungewöhnliche Paar Handschuhe, das Guixé 1999 für die Firma Camper realisiert hat. In diesem Beispiel wird die spiegelbildliche Symmetrie unserer beiden Hände zugunsten einer auf den Gebrauch gerichteten Blickweise verdrängt: Einer der Handschuhe anerkennt die übliche Unabhängigkeit unserer fünf Finger, während der andere als Fäustling nur den Daumen freilässt. Beide Möglichkeiten in einem Paar vereint verbinden zwei allgemein unvereinbare Dinge: die Feinheit des Greifens und den Erhalt der Körperwärme. Es scheint klar zu sein, dass die Asymmetrie auf keine stilistische Wirkung zurückgeht, da beide Benutzungsweisen üblich und sogar nötig sind. Weit entfernt von rein formalen Methoden und Beschäftigungen

préoccupations purement formelles, le travail de Guixé ne cesse pourtant de puiser dans les répertoires existants sans pour autant négliger les «nouvelles tendances» du design international. Guixé se sert littéralement de ce substrat et le vampirise, en suce les éléments essentiels pour permettre de dégager de nouvelles notions sur le plan de l'usage, de la responsabilité du designer et de notre relation au cadre social contemporain. Il opère ainsi des greffes improbables (une clé dont le panneton est une brosse), sort radicalement de leur contexte des éléments ultra typés (une chaise dont l'assise se construit par l'empilement de livres et de revues ou conçoit un *post-it* géant servant de protection dans l'espace urbain), met en abîme les mécanismes consuméristes (une tomate remplie de ketchup, une omelette estampillée cK), détourne nos formules publicitaires (*if you don't need it, don't buy it* pour les magasins Camper) et détourne nos habitudes ménagères (*tea for twins*: des sachets à thé pour prendre un bain de pieds). Ses créations ne sont jamais ce que l'on imagine, a priori, trouver: systématiquement, elles proposent plus ou autre chose que ce qu'elles donnent à voir. Subrepticement, elles parasitent nos réflexes, nous obligent à voir et fonctionner *autrement*.

Guixé's work never stops drawing on existing repertoires without, for all that, disregarding new trends in international design. Guixé makes literal use of this substratum and "vampirises" it, sucks from it the essential elements in order to enable him to develop novel concepts on the level of use, the responsibility of designer and user, our relationship with the other and, more generally, our relationship with the contemporary social framework. He thus effects improbable transplants (a key whose bit is a brush), takes stereotyped elements radically out of context (a chair whose seat is constructed by piling up books and magazines, or a giant Post-it serving as protection in the urban space), pushes consumerist mechanisms to the edge (a tomato filled with ketchup, an omelette stamped cK), subverts advertising formulas (*If you don't need it, don't buy it* for the Camper shops) and domestic customs (*tea for twins*: tea bags to use for a foot bath) by giving them a new physical reality. His creations are never what one imagines, a priori, that one will find: systematically, they suggest more or something other than what they present to the view. Surreptitiously, they interfere with our reflexes, oblige us to see and function *differently*.

schöpfen Guixés Arbeiten unablässig aus bestehendem Fundus, ohne deshalb die „neuen Tendenzen" des internationalen Designs zu vernachlässigen. Guixé bedient sich wortgetreu dieser Grundlage und saugt sie aus, entzieht ihr die wesentlichen Elemente, um neue Konzepte in Bezug auf Gebrauch, Verantwortung des Designers und unser Verhältnis zum zeitgenössischen gesellschaftlichen Rahmen herauszuarbeiten. Auf diese Weise operiert er mit unwahrscheinlichen Übertragungen (ein Schlüssel, dessen Bart eine Bürste ist), löst äußerst typische Elemente vollständig aus ihrem Zusammenhang (ein Stuhl, dessen Sitzfläche durch das Stapeln von Büchern und Zeitschriften entsteht, oder er konzipiert einen riesigen post-it als Schutz im städtischen Raum), verwirft Konsummechanismen (eine Tomate gefüllt mit Ketchup, ein Omelette mit dem Logo cK), verfremdet Werbesprüche (*If you don't need it, don't buy it* für die Läden von Camper) und häusliche Gewohnheiten (*tea for twins*: Teebeutel für Fußbäder), indem er ihnen eine neue Wirklichkeit verleiht. Seine Schöpfungen sind niemals das, was man sich vorstellt: sie sind mehr oder weisen über sich hinaus. Unbemerkt beuten sie unsere Reflexe aus, zwingen uns, anders zu sehen und zu funktionieren. Die zahlreichen Deklinationen zum Thema Klebeband öffnen den Weg zu ungleichartigen und nicht zueinander

Les nombreuses déclinaisons sur le thème du ruban adhésif ouvrent la voie à des extensions d'usages incongrus si l'on considère le scotch dans sa seule fonction collante. Ces bandes permettent de construire des ballons de football (*football tape*), de valoriser une image préexistante (*do frame*), de solliciter le visiteur (*guest tape*), de modifier la perception d'un environnement (*plant emulator*) ou de distiller des exercices de détente (*analgesic agent tape*). Cette attitude d'interventions décalées et environnementales a été notamment développée de manière magistrale pour les successifs aménagements des magasins Camper de par le monde. D'emblée, Guixé a réagi à ce mandat en dépassant la simple idée de décoration. Ses divers agencements proposent des concepts globaux où la présentation des souliers sert de pivot à une mise en scène basée sur l'information et le message, différents pour chaque ville. Le jeu de mot du slogan *walk in progress* pour *work in progress* est appliqué à la lettre et permet à chaque nouvelle boutique — par la présentation des produits, par l'éclairage, par l'apport de photographies, de textes, de dessins et par la réalisation de nombreux accessoires — de se distancer des conventions du marketing et de la publicité standardisés.

Numerous declensions on the theme of sticky tape open the way for hybrid extensions of use that are incongruous if one considers scotch tape solely in the light of its adhesive function. These strips permit one to construct footballs (*football tape*), to increase the status of a pre-existing image (*do frame*), to appeal to the visitor (*guest tape*), to modify perception of an environment (*plant emulator*) or to exude exercices of relaxation (*analgesic agent tape*). This attitude of dislocated and environmental interventions has been developed in a masterly manner for the successive outfitting of Camper shops throughout the world. Guixé responded straight away to this mandate by going beyond the simple idea of décor. His various layouts propose global concepts in which the presentation of shoes acts as a pivot for installations based on information and on the message, different in the case of each city. The wordplay of the Camper slogan *walk in progress* for *work in progress* is applied to the letter and permits each new shop – through product presentation, through lighting, through the contribution made by photos, texts, drawings and through the creation of numerous accessories – to distance itself from standardised marketing and advertising conventions.

passenden Gebrauchserweiterungen, wenn man den Tesafilm ausschließlich in seiner Klebefunktion betrachtet. Mit diesen Bändern lassen sich Fußbälle bauen (*football tape*), ein bereits vorhandenes Bild aufwerten (*do frame*), den Besucher auffordern (*guest tape*), die Wahrnehmung einer Umgebung verändern (*plant emulator*), oder Entspannungsübungen vormachen (*analgesic agent tape*). Diese Sicht von unerwarteten und umgebungsbezogenen Eingriffen hat er vor allem meisterhaft für die in Folge geschaffenen Einrichtungen der Camper-Geschäfte auf der ganzen Welt entwickelt. Schon beim ersten Auftrag hat Guixé reagiert, indem er über die einfache Idee der Dekoration hinausging. Seine verschiedenen Anordnungen schlagen globale Konzepte vor, bei denen die Auslage der Schuhe als Drehpunkt für eine Inszenierung dient, die je nach Stadt auf eine unterschiedliche Information und Botschaft gestützt wird. Das Wortspiel mit dem Camper Slogan *walk in progress* für *work in progress* wird wortwörtlich angewandt und erlaubt in jedem neuen Geschäft, durch die Präsentation der Produkte, die Beleuchtung, den Beitrag von Fotos, Texten, Zeichnungen und die Schaffung einer Menge Zubehörteile sich von den Konventionen von Marketing und standardisierter Werbung zu distanzieren.

Depuis longtemps, l'ex-designer (selon ses propres mots) s'est ingénié à démont(r)er le rapport ambigu entre nature et culture, cette dernière étant à ses yeux largement prédominante dans la mesure où la nature est aujourd'hui totalement colonisée par l'action de l'homme. Son intérêt pour la nourriture — le plus universel des langages du design — l'a amené à toutes sortes de propositions, non pas de type culinaire mais bien plutôt en termes de consommation et donc, d'usage. *The Kitchen-Buildings*, le projet réalisé par Guixé pour le mu.dac propose, avec son intention, une nouvelle manière d'appréhender et de consommer les aliments. Une série de dispositifs, les 7 *Kitchen-Buildings*, nous incite à utiliser des structures directement conçues pour s'intégrer à un contexte qui semble, a priori, naturel: le bois de la forêt (*Oven Kitchen-Building*), l'utilisation du soleil (*Solar Kitchen-Building*), le verger (*Fruit Kitchen-Building*), les produits de la mer (*Shellfish* et *Seafood Kitchen-Buildings*), le jardin ou le bord d'une rivière (*Garden* et *Smokehouse Kitchen-Buildings*). Mais ce *parc anthropologique en temps réel* n'est en réalité qu'une construction fictive du naturel, l'essentiel étant ailleurs à l'instar des fausses vraies confitures à l'ancienne que de

For a long time now, the ex-designer (as he terms himself) has been endeavouring to dismantle and/or demonstrate the ambiguous link between nature and culture, the latter in his eyes being largely predominant, insofar as nature today has been totally colonised by human actions. His interest in food — the most universal of the languages of design — has led him to make all sorts of propositions, not of a strictly culinary type but more in terms of consumption and therefore of use. *The Kitchen-Buildings*, the project created by Guixé for the mu.dac, in its intent proposes a new way of apprehending and consuming food. A series of seven *Kitchen-Buildings*, prompt us to use structures that are directly designed to fit into a context which appears, a priori, to be natural: timber from the forest (*Oven Kitchen-Building*), use of the sun (*Solar Kitchen-Building*), the orchard (*Fruit Kitchen-Building*), marine products (*Shellfish* and *Seafood Kitchen-Buildings*), the garden and the riverbank (*Garden* and *Smokehouse Kitchen-Buildings*). But this "anthropological park in real time" is in reality nothing but an imagined construct of the natural, the essential being elsewhere, as is the case with the fake "genuine" old-fashioned jams that a number of brands

Seit langem versucht der Ex-Designer (nach seinen eigenen Worten) mit allen Mitteln, das zweideutige Verhältnis zwischen Natur und Kultur zu zeigen und aufzuzeigen. Seiner Ansicht nach ist letztere mit Abstand in dem Maße dominierend, in dem die Natur heute gänzlich vom menschlichen Handeln erschlossen ist. Sein Interesse für Lebensmittel — die universellste Sprache, was Design betrifft — hat ihn zu den verschiedensten Vorschlägen geführt, nicht nur kulinarischer Art, sondern eher in Bezug auf den Verzehr und damit den Gebrauch. *The Kitchen-Buildings,* das von Guixé für das mu.dac realisierte Projekt, bietet mit seiner Absicht eine neue Art an, Nahrungsmittel zu begreifen und zu konsumieren. Eine Serie von Vorrichtungen, die 7 *Kitchen-Buildings*, ermuntern uns, die Strukturen zu verwenden, die unmittelbar konzipiert wurden, um sie in einen Kontext einzubinden, der auf den ersten Blick natürlich erscheint: das Holz aus dem Wald (*Oven Kitchen-Building*), die Nutzung der Sonne (*Solar Kitchen-Building*), Obstbäume (*Fruit Kitchen-Building*), Meeresprodukte (*Shellfish* und *Seafood Kitchen-Buildings*), der Garten oder das Flussufer (*Garden* und *Smokehouse Kitchen-Buildings*). Doch dieser anthropologische Park in Echtzeit ist in Wirklichkeit nur eine fiktive Konstruktion des Natürlichen: das Wesentliche ist andernorts, nach dem Muster vermeintlich echter

nombreuses marques ont lancé sur le marché depuis plusieurs années. Cette reconstruction met bien davantage l'accent sur la série d'actes que nous opérons au moment de préparer, d'élaborer et de consommer. Comme le témoignent avec malice les bandes dessinées narratives accompagnant chaque projet, l'ingéniosité et la poésie de ces étranges structures architecturales servent de ferment à la rencontre, au partage convivial et à l'activité physique des utilisateurs. Chaque *cuisine* recèle en elle des possibilités de transformation et donc d'adaptation à l'usage qu'en feront les protagonistes. Les plans et les maquettes, aux formes rigoureuses parfaitement maîtrisées, cautionnent la potentielle concrétisation architecturale du projet. Il semble que les dessins, eux, nous disent autre chose: ensemble, nous allons explorer de nouvelles manières d'approcher, de s'approprier et d'absorber ces aliments. Nous aurons la liberté de changer de contexte et surtout de sortir du cadre habituel de la cuisine et pouvoir peut-être même jouer à réinvestir *autrement* ce geste vital qui est de se nourrir, en principe, trois fois par jour. Cette première exposition personnelle de Guixé dans un musée est axée sur ce projet original. *Kitchen-Buildings* est

have launched on the market over the last few years. This reconstruction puts the accent more on the series of acts that we carry out at the moment of preparing, elaborating and consuming. As the narrative cartoon strips accompanying each project mischievously testify, the ingenuity and the poetry of these strange architectural structures act as a leaven for the encounter, the convivial sharing of food and the users' physical activity. Each kitchen harbours within itself possibilities for transformation and thus for adaptation to the use that the protagonists will make of it. Plans and models, their rigorous forms perfectly mastered, guarantee the potential concrete architectural realisation of the project. But it seems that the drawings themselves tell us something else: together, we are going to explore new ways of approaching, of appropriating and of absorbing food. We will have the freedom to change the context and, in particular, to emerge from the customary framework of the kitchen, even perhaps be able to play at reinvesting *differently* this vital gesture – which is to feed oneself, in principle, three times a day. This first personal exhibition by Guixé in a museum is centred on this original project. *Kitchen-Buildings* is associated in parallel with

Fruchtmarmeladen nach Großmutters Art zu finden, die viele Hersteller vor Jahren auf den Markt brachten. Diese Rekonstruktion legt den Akzent mehr auf all jene Handlungen, die wir beim Zubereiten, Verfeinern und Verzehren ausführen. So wie es die Bildergeschichten zu jedem Projekt schelmisch bezeugen, dienen der Einfallsreichtum und die Poesie dieser seltsamen architektonischen Strukturen als Ferment der Begegnung, des geselligen Beisammenseins und der körperlichen Aktivität der Nutzer. Jede Küche birgt Möglichkeiten der Umwandlung und daher der Anpassung an den Gebrauch durch die Hauptdarsteller. Die Pläne und Modelle mit streng genauen, perfekt beherrschten Formen garantieren bei Bedarf eine architektonische Konkretisierung des Projekts. Es scheint, dass die Zeichnungen uns etwas anderes sagen: Gemeinsam werden neue Herangehensweisen erforscht, um sich diese Nahrungsmittel anzueignen und zu sich zu nehmen. Wir werden die Freiheit haben, die Umgebung zu verändern und vor allem den üblichen Rahmen der Küche zu verlassen, und können vielleicht damit spielen, diese lebensnotwendigen Handlungen in etwas anderes überzuleiten als sich dreimal täglich zu ernähren. Die erste Einzelausstellung Guixés in einem Museum richtet sich auf dieses Originalprojekt. *Kitchen-Buildings* wird parallel mit einer Serie noch unveröffentlichter

parallèlement associé à une série de créations non encore publiées. Cet ouvrage et cette présentation ne doivent pas être perçus comme un mode d'emploi donnant une lecture linéaire de la riche production du designer catalan. A l'instar des nombreuses chartes graphiques associées à ses créations (*Instruction Cards*), sortes de dérivés ironiques des consignes de sécurité pour les passagers d'avions, ce choix propose plutôt un kaléidoscope de projets aux règles basées sur la narration imagée et sur la participation et la responsabilité de l'utilisateur. Chez Guixé, l'objet et son usage ne cessent de se donner la réplique. Les graines formant les yeux des personnages/produits *Plant-me-Pets* doivent littéralement disparaître en étant plantées en terre pour donner naissance au nouvel *objet* consommable que sera, *in fine*, le légume. Entre nature et culture, les règles du jeu restent ouvertes: l'usage en décidera. _Chantal Prod'Hom, Directrice du mu.dac

a series of so far unpublished creations. This work and this presentation should not be perceived as "directions for use" giving a linear reading of the Catalan designer's rich production. After the fashion of the numerous graphic charts (*Instruction Cards*) associated with his creations, a sort of ironic derivative of airline safety cards, this choice instead proposes a kaleidoscope of projects with rules based on illustrated narration and on participation and responsibility on the part of the user. With Guixé, the object and its use never stop responding to one another, giving mutual feedback. The seeds that form the eyes of the *Plant-me-Pets* characters/products must literally disappear when planted in the ground in order to give birth to the new consumable *object*, which ultimately will be the vegetable. Between nature and culture, the rules of the game remain open: the use will decide. _Chantal Prod'Hom, Director of mu.dac

Arbeiten gezeigt. Dieses Werk und seine Präsentation dürfen nicht als Gebrauchsanweisung verstanden werden, welche die umfangreiche Produktion des katalanischen Designers linear ablesbar macht. Ebenso wie viele grafische Darstellungen, die mit seinen Arbeiten (*Instruction Cards*) assoziiert werden, Arten ironischer Ableitungen von Sicherheitsanweisungen für Flugzeugpassagiere, schlägt diese Auswahl eher ein Kaleidoskop von Projekten mit Regeln vor, die auf der bebilderten Erzählung sowie der Beteiligung und der Verantwortung des Benutzers basieren. Bei Guixé hören das Objekt und sein Gebrauch nicht auf, einander zu antworten. Die Getreidekörner, welche die Augen der Personen/Produkte *Plant-me-Pets* bilden, müssen buchstäblich verschwinden, wenn sie in die Erde gepflanzt werden, um das neue verzehrbare *Objekt* hervorzubringen, welches *in fine* das Gemüse sein wird. Zwischen Natur und Kultur bleiben die Rollen offen: Der Gebrauch wird darüber entscheiden. _Chantal Prod'Hom, Direktorin des mu.dac

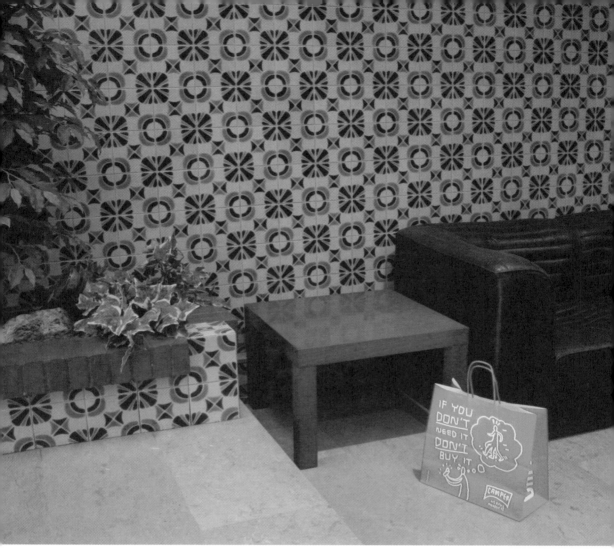

A une certaine époque (dans les années quatre-vingt) je concevais des notices techniques pour produits électroniques. J'ébauchais à grands traits une maquette qu'un dessinateur reprenait proprement au stylo Rotring. Je fais généralement des croquis rapides pour noter des idées ou des situations. Ces croquis tiennent à la fois de la bande dessinée et du manuel d'instructions techniques. Ces notes rapides sont désormais des œuvres à part entière: achevées, originales. Je ne dessine plus sur papier: je travaille directement sur tablette graphique. _If you don't need it, don't buy it / **Affiches et sacs pour Camper, 2002–2003**

For a period of time I did instruction manuals for electronic goods, sketching the storyboard for someone else to redo more cleanly with a Rotring pen (this was in the 80s). I normally do very rapid sketches to note down ideas or situations. These drawings are a hybrid between a comic sketch and user's instructions. These annotations have eventually become finished, original works. I no longer draw on paper; now I do everything directly with a digital graphics tablet. _If you don't need it, don't buy it / **Posters and bags for Camper, 2002–2003**

Eine Zeit lang machte ich Bedienungsanleitungen für elektronische Geräte und entwarf das Storyboard für jemand anderen, der es nochmals mit einem Rotring-Stift sauber bearbeitete (das war in den achtziger Jahren). Normalerweise fertige ich sehr schnell Skizzen an, um Ideen oder Situationen festzuhalten. Diese Zeichnungen sind ein Mittelding zwischen einem Comicentwurf und einer Gebrauchsanweisung. Aus diesen Anmerkungen werden schließlich selbstständige Werke. Ich zeichne nicht mehr auf Papier, sondern direkt auf einem digitalen Grafiktablett. _If you don't need it, don't buy it / **Poster und Taschen für Camper, 2002–2003**

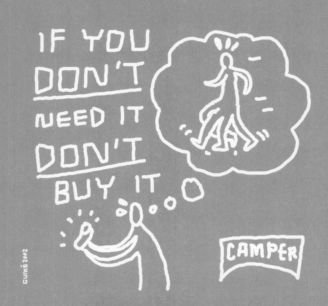

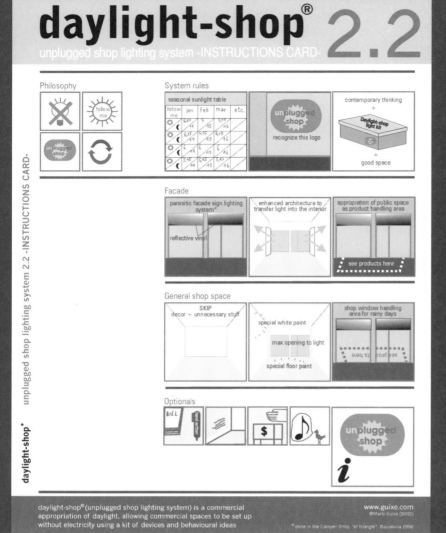

Il s'agit ici de consignes d'instructions destinées à activer un système parallèle à celui qui contrôle l'éclairage traditionnel des locaux commerciaux. A la fois plus logique et plus écologique, il repose sur l'utilisation de la lumière du jour. _Daylight Shop Card / Projet, 2002

This is an instructions card for a system parallel to conventional commercial lighting. It is more logical and ecological, based as it is on the use of daylight. _Daylight Shop Card / Project, 2002

Hierbei handelt es sich um eine Anleitungskarte für eine Geschäftsbeleuchtung, das parallel zum herkömmlichen gedacht ist. Es ist logischer und ökologischer, da es auf der Nutzung von Tageslicht basiert. _Daylight Shop Card / Projekt, 2002

Deterritorializing Contents

Indoor-Publishers consider themselves a platform for publications that fill rooms with contents

INDOOR-PUBLISHERS

The concept presented here is Indoor Publishing. Indoor-Publishers seek to enable authors to take over spaces with their own contemporary ideas where previously the room's surfaces were dominated by decorative elements and material. The concept is applicable to public as well to private rooms.

Authors and Indoor-Publishers
The specific interest of Indoor-Publishers consists in publishing authors. This refers to already existing or prepared work as well as to ideas and drafts commissioned by Indoor-Publishers.

The Room's Owner and Indoor-Publishers
Instead of investing in decoration and representation, the room's owner sponsors an author who composes an issue to be published on the walls of the room. The investment is carried out in the form of culture.

To facilitate implementation, Indoor-Publishers arranges for a professional team.

auf Deutsch

contact: info / publisher / editor

Concept: décoration = information, information = décoration. L'idée est ici de détourner de leur fonction première des budgets destinés aux matériaux, aux détails et éléments mobiliers afin de laisser la place à un message intellectuel rédigé par des écrivains. Ces projets rédactionnels sont financés par un sponsor dont la contribution assure la couverture complète de l'espace dédié à l'écriture. Enfin, l'espace donné est consacré à la totalité d'un texte d'auteur. _Projet, 2001 / Avec Inga Knölke

Decoration as information and information as decoration: the idea is to reroute the budgets used for materials, constructed details and furniture elements so that authors can develop content; their projects are thus sponsored by someone who has the funds to fill a space. In the end the given space is filled with the content the author has prepared. _Project, 2001 / With Inga Knölke

Dekoration als Information und Information als Dekoration: Die für Materialien, Konstruktionsdetails und Möbelelemente aufgewandten Budgets sollen so umgeleitet werden, dass Autoren Inhalt entwickeln können; ihre Projekte werden folglich von jemandem gesponsert, der über die Mittel verfügt, um einen Raum zu füllen. Schließlich wird der gegebene Raum mit dem vom Autor vorbereiteten Inhalt gefüllt. _Projekt, 2001 / Mit Inga Knölke

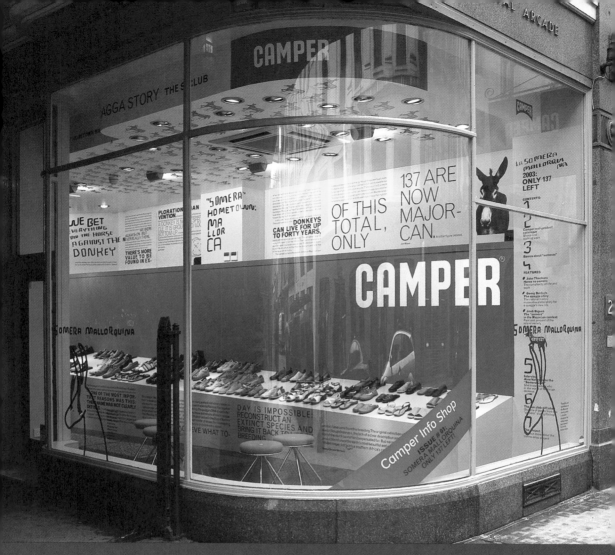

CAMPER, 28 OLD BOND STREET, LONDON INFO-SHOP #001

_ L'INFO-SHOP CAMPER DE LONDRES

L'idée d'utiliser l'information comme thème de décoration n'est pas nouvelle chez Camper: dans la boutique Camper situées dans «el triangle» de Barcelone (1998), les murs ne sont pas simplement des supports pour photographies, ils sont entièrement recouverts de photographies. L'adjonction de textes et dessins exécutés à la main caractérise la boutique du quartier de Soho à New York (2000). Dans «Walk in progress» un espace était réservé à la messagerie (1999).

Camper est également connu pour la typographie qui caractérise ses affiches, sacs et publications diverses.

Le concept de l'info-shop vise à étendre ces caractéristiques autant que faire se peut et générer ainsi une nouvelle typologie de boutiques basées sur le concept d'«information = décoration» et «décoration = information».

_ LE CONCEPT DE L'INFO-SHOP: LES IDÉES SE SUBSTITUENT AUX CONVENTIONS

Le concept de base est de remplacer les matériaux coûteux, les détails structuraux et les éléments exclusifs complexes de la décoration par de l'information. De cette manière, le budget normalement consacré aux matériaux et à la finition soignée est investi dans l'élaboration d'un message intellectuel, qui sera rédactionnel ou visuel.

Il est important que cette information soit indépendante de la publicité créée explicitement pour la marque.

La boutique est réalisée avec des matériaux, des éléments d'éclairage et autres qui sont standard et respectueux de l'environnement. C'est dans ce contexte qu'interviendra le message du créateur. Ce message sera élaboré indépendamment au niveau graphique, et appliqué ensuite selon le protocole défini pour ce type d'espace commercial.

Le créateur peut, de la sorte, être toute personne qui a un message intéressant ou important à communiquer, et qui cherche à exprimer un point de vue.

_ INFO-SHOP AND CAMPER

The idea of working with information as decoration is not new for Camper. By way of example, in the shop at Barcelona's "el triangle" (1998), the walls are not simply supports for photographs but are totally covered with photography. The application of hand-done text and drawing is seen in the New York Soho shop (2000), while the space reserved to leave messages was used in the "Walk in progress" (1999).

Camper is also known for its graphic production, as appearing on posters, bags and other publications.

The idea of the info-shops is to take these characteristics to an extreme, bringing them all together to create a new typology of shop based on the concept of information as decoration and decoration as information.

_ THE INFO-SHOP CONCEPT: IDEAS SUBSTITUTE CONVENTION

The basic idea is to substitute costly material, complex constructive details and exclusive elements with information. In this way the budget that is normally set aside for materials and finely-crafted finishing goes instead to the construction of intellectual content, whether written or visual.

It is important that this information is not tied into an explicit advertisement for the brand.

The shop is constructed with materials, lighting elements and other elements that are standard and environmentally friendly. Onto this ground the content developed by the creator is applied.

This content will be independently developed on a graphic level and will be applied according to concrete criteria as defined for this type of commercial space.

The creator can thus be any person who has something interesting or important to say and seeks to express an opinion.

The project emulates a structure similar to (though more complex than) the publication of a creatively produced book.

_ INFO-SHOP UND CAMPER

Information als Dekoration zu verwenden, ist für Camper nicht neu. So dienen beispielsweise die Wände im Geschäft von Barcelonas „el triangle" (1998) nicht bloß als Träger für Fotografien, sondern sind gänzlich mit Fotos bedeckt. Handgefertigte Texte und Zeichnungen sind im New Yorker Soho Shop (2000) zu sehen während die Raumwände in den „Walk in progress" Shops für Mitteilungen der Kunden freigelassen sind.

Camper ist auch für seine grafische Produktion bekannt wie sie auf Postern, Taschen und anderen Publikationen erscheint.

Die Idee der Info-Shops ist, diese Kennzeichen bis zum Extrem zu treiben. Alle vereint sollen eine neue Laden-Typologie schaffen, die auf dem Konzept der Information als Dekoration und der Dekoration als Information basiert.

_ DAS INFO-SHOP-KONZEPT: IDEEN ERSETZEN KONVENTION

Die Grundidee ist, teures Material, komplexe Konstruktionsdetails und exklusive Elemente durch Informationen zu ersetzen. Auf diese Weise fließt das gewöhnlich für Materialien und eine feine Bearbeitung aufgewendete Budget in die Konstruktion eines intellektuellen, geschriebenen oder bildlichen Inhalts.

Wichtig ist, dass diese Informationen nicht an eine eindeutige Werbung für die Marke gebunden sind.

Der Laden ist mit Materialien, Beleuchtungskörpern und anderen Bauteilen gestaltet, die standardisiert und umweltfreundlich sind. Auf dieser Grundlage wird der vom Schöpfer entwickelte Inhalt angewandt.

Dieser Inhalt wird auf einer grafischen Ebene unabhängig entwickelt und konkreten Kriterien entsprechend umgesetzt, die für diesen Typ von Geschäftsraum definiert sind.

Jede beliebige Person kann daher der Schöpfer sein, jeder, der etwas Interessantes oder Wichtiges zu sagen hat und seine Meinung äußern möchte.

Le projet est semblable (bien que plus complexe) à la structure d'un livre d'artiste.

L'objectif visé par le projet «info-shops» est d'ouvrir Camper à toutes les personnes créatives qui ont des idées à apporter — et non pas aux seuls designers — en vue de contribuer à l'évolution de ses succursales «info-shop». Ces collaborateurs pourront être agriculteurs, sportifs professionnels, touristes ou cuisiniers.

«SOMERA MALLORQUINA» 2003: ONLY 137 LEFT

L'âne de Majorque est une espèce locale menacée d'extinction. En 2003, le nombre de ces ânes pur-sang n'est plus que de 137.

L'idée du projet est de créer une image de marque «Somera Mollorquina» (âne de Majorque) afin que, dans l'hyper-réalité de la publicité, celui-ci puisse acquérir le statut de «denrée de luxe». Devenu de ce fait un «objet culte», sa survie dans le monde de la réalité sera assurée.

_ CONTEXTE DU THÈME DE L'INFO-SHOP CAMPER DE LONDRES

Camper est une entreprise de l'île de Majorque qui a déjà utilisé l'image de l'âne de Majorque dans ses campagnes publicitaires, mais de manière anecdotique seulement.

L'intérêt réside ici dans la présentation d'une espèce d'équidé menacée d'extinction au cœur d'un pays (Londres, 28 Old Bond Street) d'ancienne tradition hippique.

_ LE THÈME

Réflexions et spéculations sur l'avenir de l'âne de Majorque, dont l'espèce est en péril, mais dont l'image dépasse sa condition naturelle.

Texte de John Thackara, fondateur de Doors of Perception / Le cheval et/ou l'âne dans le contexte de l'économie nouvelle

Texte de Georg-Christof Bertsch, rédacteur publicitaire, fondateur-propriétaire de Bertsch & Bertsch, conseil en communication, Francfort. / Sur l'extinction de la quagga en 1878

The final idea of the info-shops project is to open Camper up to collaborations from any creative person with ideas (and not just designers) in the development of their info-shop commercial outlets. This person could thus be a farmer, an athlete, a tourist or a cook.

_ "SOMERA MALLORQUINA" 2003: ONLY 137 LEFT

The Majorcan donkey is a local species, with only 137 pure-bred individuals left in 2003.

The idea of the project is to create a brand image of the "Somera Mallorquina" (Majorcan Donkey), so that within this hyper-reality it might acquire the status of a "luxury object" and in consequence a "cult object", thus ensuring that it does not disappear from the real world.

_ CONTEXT OF THE CAMPER LONDON INFO-SHOP THEME

Camper is an enterprise from the island of Majorca which has already used the image of the Majorcan donkey in its advertising campaigns, though only in an anecdotal manner.

The interest here lies in the tension of the theme proposed for the Camper shop at 28 Old Bond Street in London, in a country with a long tradition centred on the horse.

_ THE THEME

Thoughts and hypotheses on the Majorcan donkey, which is about to disappear but whose image goes beyond its strictly natural state.

Text by John Thackara, founder of Doors of Perception / Horse vs. Somera in the context of the new economy

Text by Georg-Cristof Bertsch, design writer, founder-owner of the Frankfurt-based brand strategy firm Bertsch & Bertsch / On the extinction of the quagga in 1878

Text by Jordi Bigues, journalist and activist in environmental and cultural issues / On the "Somera" in the Majorcan context

Interview with Aina Vallespir / Aina Vallespir lives in Majorca. She is an environmental farmer and stage actress, and works as the

Das Projekt strebt nach einer ähnlichen (obwohl komplexeren) Struktur wie die Veröffentlichung eines kreativ hergestellten Buchs.

Das Konzept für das Info-Shop-Projekt besteht vor allem in der Zusammenarbeit von Camper mit kreativen Personen, die einen speziellen Inhalt ausarbeiten und ihn im kommerziellen Kontext des Info-Shop publizieren. Eine solche Person könnte daher ein Landwirt, ein Athlet, ein Tourist oder ein Koch sein.

_ „SOMERA MALLORQUINA" 2003: ONLY 137 LEFT

Der mallorquinische Esel ist eine Lokalspezies mit nur 137 reinrassigen Individuen, die 2003 noch leben.

Das Konzept sieht die Schaffung eines Markenimages für den „Somera Mallorquina" (Mallorquinischer Esel) vor. In dieser Hyperrealität könnte er den Status eines „Luxusobjekts" und folglich eines „Kultobjekts" annehmen, womit sichergestellt wäre, dass er aus der realen Welt nicht verschwindet.

_ KONTEXT ZUM THEMA DES CAMPER INFO-SHOPS LONDON

Camper ist ein Unternehmen aus Mallorca, welches das Bild des mallorquinischen Esels bereits in seinen Werbekampagnen eingesetzt hat, allerdings nur in anekdotischer Form.

Das Interesse liegt hier in der thematischen Spannung, die für den Camper-Laden in 28 Old Bond Street in London vorgeschlagen wurde, in einem Land mit einer langen, auf das Pferd ausgerichteten Tradition.

_ DAS THEMA

Gedanken und Hypothesen über den mallorquinischen Esel, der im Begriff ist zu verschwinden, dessen Image jedoch über seinen naturbezogenen Status hinausgeht.

Text von John Thackara, Gründer von Doors of Perception / Pferd versus mallorquinischer Esel im Kontext der New Economy

Text von Georg-Cristof Bertsch, Designautor, Gründer und Inhaber des in Frankfurt ansässigen Markenstrategie-Unternehmens Bertsch &

Texte de Jordi Bigues, journaliste militant pour la sauvegarde de l'environnement et de la culture. A propos de la «Somera» dans le contexte de Majorque.

Entretien avec Aina Vallespir / Aina Vallespir vit à Majorque. Elle s'occupe d'agriculture écologique, actrice de théâtre, elle tient également le poste de secrétaire de l'ACRIPOASMA (Association des éleveurs et propriétaires d'ânes pur-sang de Majorque).

Données et statistiques sur les ânes de Majorque, extraites d'un texte publié par l'ACRIPROASMA / Boutique cadeau pour les fans
_ L'ESPACE

L'espace commercial se fond dans le décor porteur du message. Un index est donné à lire sur le devant de la boutique. Dans les vitrines se trouvent le titre et l'introduction qui font ainsi office de première page. Les textes des différents auteurs sont dispersés dans l'espace entier, sol compris. Les images de «someras» veulent être une idéalisation de l'espèce. Ceci vaut également pour les dessins qui représentent l'équidé aux gestes «humanisés».

Au plafond 137 icônes représentent les 137 ânes de l'espèce en péril, chacun accompagné du nom que lui a donné son propriétaire.

L'espace comporte également des photographies de quaggas suivies du nom des villes dont le musée rend hommage à la quagga et où, simultanément, Camper a une boutique.

Comme il se doit, l'image de la marque est présente dans la zone d'exposition du produit.

Les sacs Camper ont été spécifiquement conçus pour la succursale londonienne. Toutes les informations disponibles dans l'espace boutique sont reproduites sur les sacs. Si vous faites un achat vous emportez l'info-shop avec vous sous forme portable.
_ **Martí Guixé, 2003**

secretary of the "Association of Breeders and Owners of Purebred Majorcan Donkeys", ACRIPOASMA.

Facts about Majorcan donkeys, extracted from a text from the association ACRIPROASMA / As well as the fan gift-shop
_ THE ROOM

The functional part of the commercial space does not disappear, being instead merged with the relevant information.

The index is found in the front part of the shop. On the shop windows the title and introduction are found, serving as the front page.

The texts of the contributors are distributed throughout the space, including the floor.

The images of the "someras" have the aim of idealising them. This is the case with the drawings as well, which represent an animal that has been "humanised" in its gestures.

On the ceiling there are 137 icons which represent the 137 individual donkeys left of the local species, each with the name given it by its owner.

The space also includes photographs of quaggas with the name of the city where museums exhibiting them can be found. In this case the photos of quaggas have been taken from cities where Camper has shops.

Logically the brand image is present, along with the display area for the product.

Camper bags have been made especially for this store. All the information found in the display area has been reproduced on them as well, so if you make a purchase the info-shop can be taken home in bag form.
_ **Martí Guixé, 2003**

Bertsch / Über die Ausrottung des Quagga 1878

Text von Jordi Bigues, Journalist und Aktivist in Umwelt- und Kulturfragen / Über den mallorquinischen Esel

Interview mit Aina Vallespir / Aina Vallespir lebt auf Mallorca. Sie ist Ökolandwirtin und Bühnenschauspielerin und arbeitet als Geschäftsführerin von ACRIPOASMA (Vereinigung der Züchter und Besitzer der reinrassigen mallorquinischen Esel).

Fakten über mallorquinische Esel, Auszug aus einem Text der ACRIPOASMA / Ebenso der Fan-Geschenkartikelladen
_ DER RAUM

Der funktionelle Teil des Verkaufsladens verschwindet nicht – er wird mit der wesentlichen Information verbunden.

Das Inhaltsverzeichnis findet sich im vorderen Teil des Ladens. Auf den Ladenfenstern sind der Titel und die Einführung zu lesen; sie dienen als Titelseite.

Die Texte der Autoren sind im gesamten Raum verteilt, einschließlich des Fußbodens.

Die Bilder der „someras" sollen sie idealisieren. Dies gilt auch für die Zeichnungen, die ein in seiner Gestik „vermenschlichtes" Tier darstellen.

An der Decke repräsentieren 137 Icons die 137 von der Lokalspezies übrig gebliebenen einzelnen Esel, jeder mit dem von seinem Besitzer vergebenen Namen.

Man findet auch Fotos von Quaggas mit dem Namen der Stadt, in der sie in den Museen ausgestellt werden. In diesem Fall stammen die Fotos aus Städten, in denen Camper Läden hat. Selbstverständlich ist das Markenimage zusammen mit der Auslagefläche für das Produkt präsent. Speziell für dieses Geschäft sind Camper-Taschen angefertigt worden. Alle Informationen, die im Raum sichtbar sind, sind auch auf ihnen wiedergegeben, sodass bei einem Einkauf der Info-Shop in Taschenform mit nach Hause genommen werden kann.
_ **Martí Guixé, 2003**

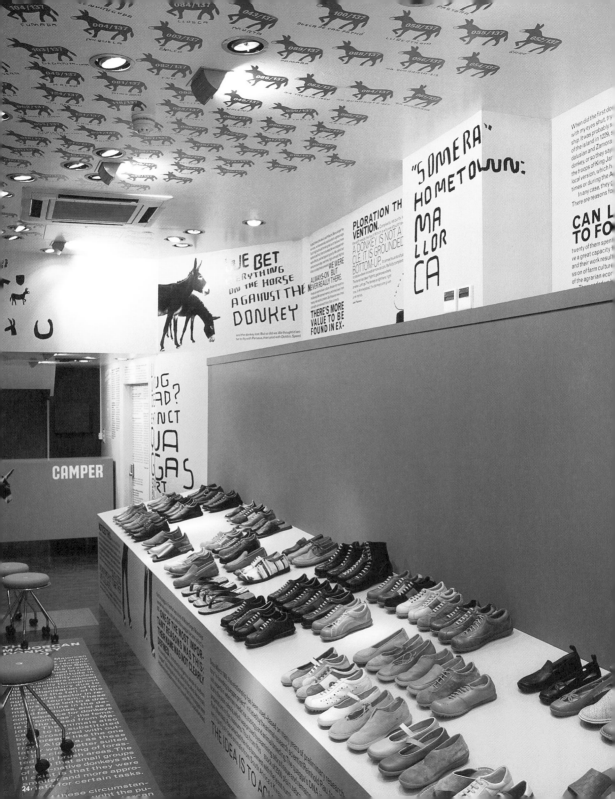

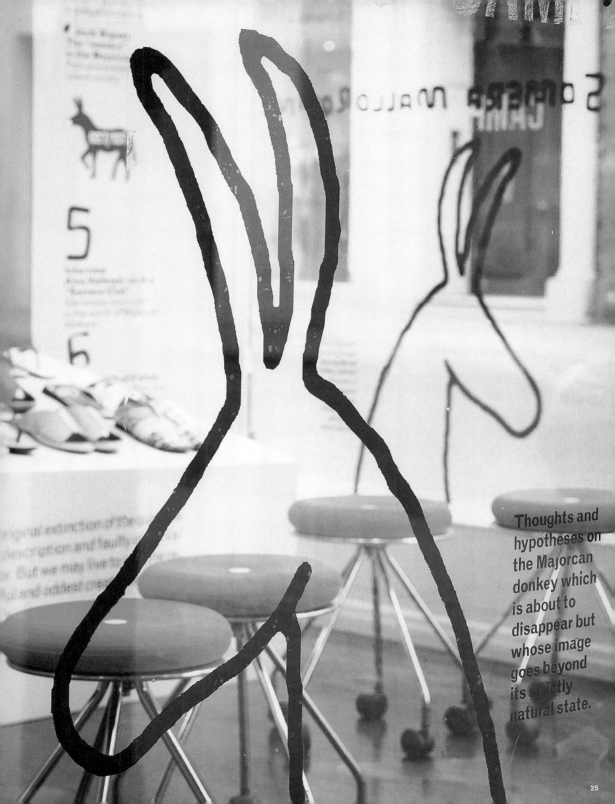

Thoughts and hypotheses on the Majorcan donkey which is about to disappear but whose image goes beyond its strictly natural state.

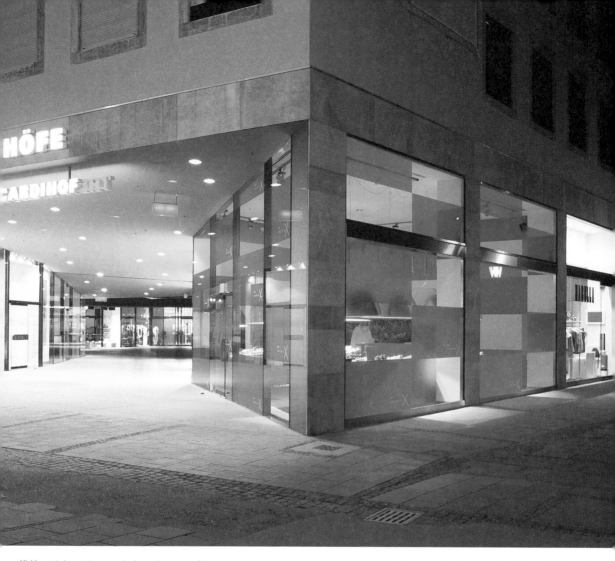

L'idée est de mettre sur pied une boutique Camper qui soit un point de rencontre. L'emplacement de la boutique est à cet égard idéal car elle est située au premier carrefour de la Ludwigstrasse lorsqu'on l'emprunte en direction du centre. Un «motif signalant un obstacle» convertit graphiquement la boutique en icône qui permet aux piétons de se retrouver dans le centre de Munich. Son rôle est semblable à celui de la fontaine Fischbrunnen, de la Marienplatz.
Le motif est facile à identifier visuellement car il évoque le drapeau de Bavière (Duché de Bavière, 1340), mais avec les couleurs de Camper.

The idea is to set up a meeting-point Camper shop. The location of the shop makes it ideal, as it is the first point you come across going from Ludwigstrasse towards the centre. Through an "obstruction marking" pattern the shop is graphically converted into an icon to aid people to meet up in the centre of Munich, an alternative to Fischbrunnen in Marienplatz.
The pattern is a very easy system of visual identification which makes reference to the Bavarian flag (Duchy of Bavaria, 1340), though with the colours of Camper.

Treffpunkt Camper Shop: Der Standort des Ladens ist ideal, da er der erste Anlaufpunkt auf dem Weg von der Ludwigstraße zum Zentrum ist. Durch das Muster „obstruction marking" wird das Geschäft grafisch in eine Ikone verwandelt, um den Menschen zu helfen, sich im Zentrum von München zu treffen, eine Alternative zum Fischbrunnen auf dem Marienplatz.
Das Muster ist ein sehr einfaches System der visuellen Erkennung: es spielt auf die Bayerische Flagge an (Herzogtum Bayern, 1340), allerdings in den Farben von Camper.

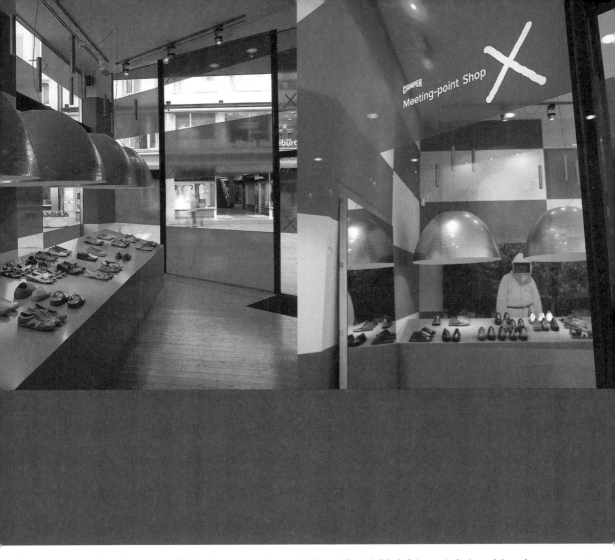

Ce dispositif est également un moyen d'attirer les gens vers le magasin. Le motif est visible à distance et c'est vers lui que le promeneur se rapproche sans rien distinguer de l'espace commercial à proprement parler. Mais pour le marcheur arrivé au point de rencontre, l'intérieur du magasin se révèle entièrement au regard car chaque élément est suffisamment large. L'effet produit est du type «générateur de curiosité». _Camper Munich à Fünf Höfe, 2003

The pattern is also a system of attraction. You see the pattern from far off and it draws you closer. As you move through an intermediate distance you cannot identify the interior space. Yet once you are near you can see the inside of the shop perfectly well, since the elements are large enough. The effect is of a type of "curiosity generator". _Camper Munich at Fünf Höfe, 2003

Das Muster ist auch ein System der Attraktion. Es ist von weitem zu sehen und wirkt anziehend. Aus einer mittleren Entfernung lässt sich der Innenraum nicht wahrnehmen. Sobald man jedoch in die Nähe kommt, ist das Ladeninnere sehr gut zu erkennen, da die Elemente groß genug sind. Die Wirkung ist die einer Art „Neugier-Erzeuger". _Camper München in Fünf Höfe, 2003

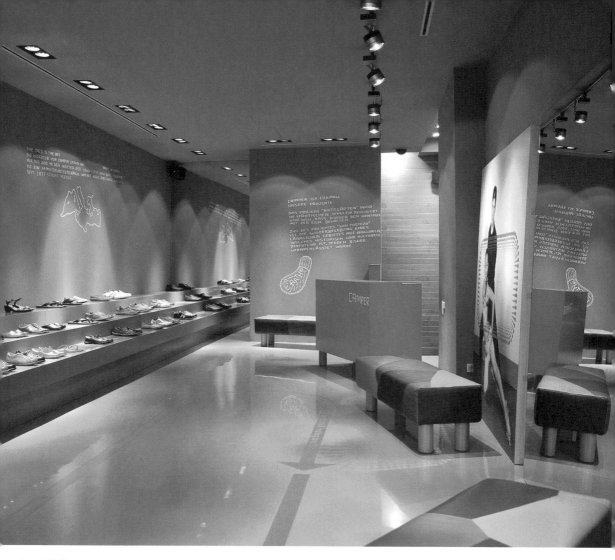

Les statistiques nous apprennent que le pourcentage des ventes des bouteilles de vin est supérieur lorsque l'étiquette présente des dorures. J'ai travaillé sur cette idée pour Camper Francfort en gardant à l'esprit le contexte spécifique de la Goethestrasse.
L'espace, conçu dans le style du «Best-Seller Camper Shop», est doté d'éléments dorés. On retrouve ceux-ci dans le logo, à l'extérieur, dans d'autres détails de la décoration et dans les zones de textes manuscrits. Ces derniers se veulent une redéfinition du luxe, mais basés sur

Statistics tell us that bottles of wine will sell a certain percentage better if they have some golden element on their labels. I worked with this idea at Camper Frankfurt, keeping in mind the context, as it is found on Goethestrasse.
The space is based on the layout of the "Best-Seller Camper Shop", though it includes golden elements: the logo on the outside, other elements, and areas of text which are hand-written. The manuscript text is thus a redefinition of luxury, based on the idea of not following

Statistiken zufolge lassen sich Weinflaschen besser verkaufen, wenn ihre Etiketten irgendein goldenes Element aufweisen. Mit dieser Idee arbeitete ich bei Camper in Frankfurt, wobei ich den Kontext im Auge behielt, da der Laden in der Goethestraße liegt.
Der Raum basiert auf dem Layout des „Best-Seller Camper Shop", obwohl er goldene Elemente beinhaltet: das Logo außen, andere Elemente und Flächen mit handgeschriebenem Text. Das Manuskript ist somit eine Neudefinition von Luxus und beruht auf dem Gedanken, nicht der

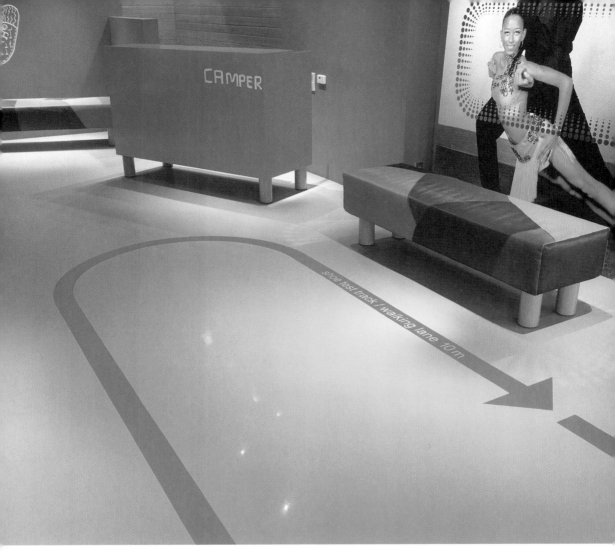

l'idée de rupture avec la tradition et de rejet de la perfection typographique classique. On a donc opté là pour le caractère non fini du travail manuel et la résistance aux protocoles traditionnels. _Camper sur Goethestrasse, Francfort, 2002

convention and rejecting the need for good finishing, opting rather for the imperfection of manual labour and resistance to protocols. _Camper at Goethestrasse, Frankfurt, 2002

Konvention zu folgen und die Notwendigkeit einer guten Oberflächenbehandlung zu verneinen. Die Unvollkommenheit der Handarbeit und der Widerstand gegen das Zeremonielle sind vorzuziehen. _Camper in Goethestraße, Frankfurt, 2002

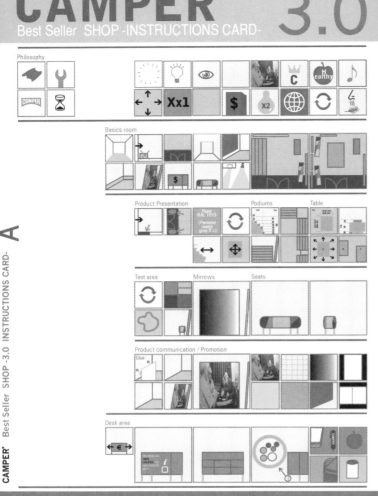

For **CAMPER** use only CAMPER

www.guixe.com
©Martí Guixé (2001)

Il s'agit ici d'un second projet de consignes d'instruction destiné à l'élaboration des espaces commerciaux de Camper. Son utilisation est destinée au développement de magasins très fonctionnels. Le système, inspiré du concept de base appliqué dans les boutiques Camper, est repensé en vue d'en réduire la superficie, d'en accroître la modernité et la fonctionnalité en termes ergonomiques et économiques à la fois. L'image de base est simple; elle change en fonction du contexte. En esprit, ces espaces commerciaux s'apparentent aux installations d'artistes et constituent par là une entorse aux conventions. Les éléments de la décoration ne tiennent pas compte de l'espace

This is a second project of *instruction cards* for the elaboration of Camper commercial spaces. The use refers to the development of highly functional shops. The system, as based on earlier shops, is rethought with the idea of reducing them, updating them and making them more functional on an ergonomic and economic level. The image is casual and changes in function of the images that are applied. These commercial spaces thus approach installations, shunning convention; the elements ignore the space inside and are to a certain degree individuals in themselves.

Das ist ein zweites Projekt aus Anleitungskarten für die Ausarbeitung von Camper-Verkaufsräumen. Die Verwendung bezieht sich auf die Entwicklung von höchst zweckmäßigen Läden. Das auf früheren Geschäften basierende System wurde unter dem Aspekt überdacht, diese zu verkleinern, zu aktualisieren und sie auf ergonomischer und wirtschaftlicher Ebene funktioneller zu machen. Der Eindruck ist zwanglos und ändert sich in Abhängigkeit von den angewandten Bildern. Diese Geschäftsräume ähneln daher eher Installationen und vermeiden Konventionen: Die Elemente sind vom Rand in einer gewissen Weise unabhängig, sie bilden quasi einen neuen Raum in diesem.
Derzeit wird das System als Basis für die Ausführung vieler Camper-Filialen genutzt; da es recht offen ist, ermöglicht es zahlreiche

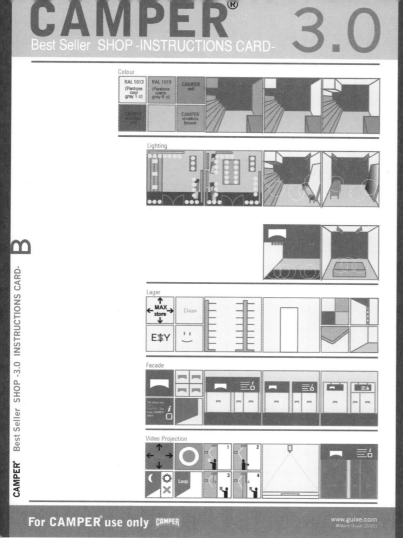

intérieur et sont dans une certaine mesure des créations à part entière.

Actuellement ce système de carte permet la rénovation de nombreuses boutiques Camper; très ouvert, il permet d'innombrables variations exigées par la diversité des contextes. Depuis peu on voit apparaître sur les murs, à côté des panneaux photographiques habituels, davantage d'éléments graphiques et textuels. _**Projet pour Camper, 2001**

Currently the system is used as the basis for carrying out many of Camper's commercial spaces; as it is quite open it allows for many variations, depending as they do on a multitude of factors. Lately it is habitual to see the inclusion of more graphic and text elements on the walls, apart from the usual photographic panels. _**Project for Camper, 2001**

Variationen in Abhängigkeit von einer Vielzahl von Faktoren. Abgesehen von den üblichen Fototafeln sieht man neuerdings ständig mehr grafische und textliche Elemente an den Wänden. _**Projekt für Camper, 2001**

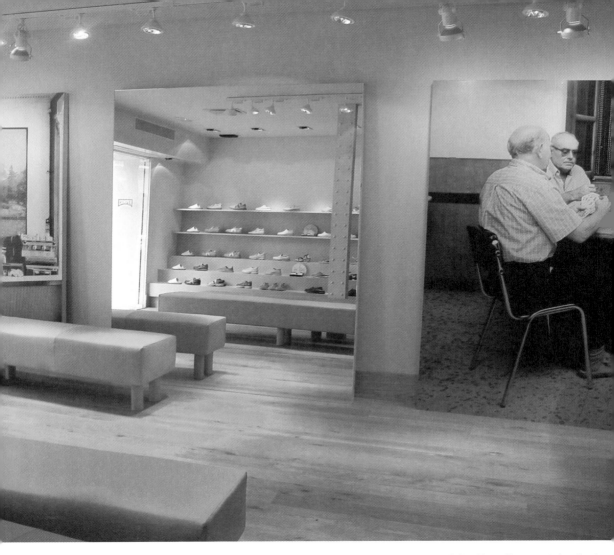

Après Rome, la boutique Camper de Madrid a été une des premières à reprendre le concept de «Best-Seller Shop». L'image est plus directe, boutique 1:1 sans fausses décorations visant à faire acheter. Leur fonctionnalité, quasi organique, recourt à un langage clair et précis. _Camper sur Calle Princesa 75. Madrid, 2001

After Rome, this shop in Madrid was one of the first shops where the Best-Seller Shop concept was applied. The image is of a more direct, 1:1 shop without false decoration trying to sell something, highly vital in its functionality and using clear, precise language. _Camper at Calle Princesa, 75. Madrid, 2001

Nach Rom war dieser Shop in Madrid einer der ersten Läden, in denen das Konzept des Best-Seller Shop angewandt wurde. Der Eindruck: ein unmittelbares 1:1-Geschäft ohne falsche Dekoration, das nur etwas zu verkaufen versucht, sehr lebendig in seiner Funktionalität und im Ausdruck klar und genau. _Camper auf der Calle Princesa, 75. Madrid, 2001

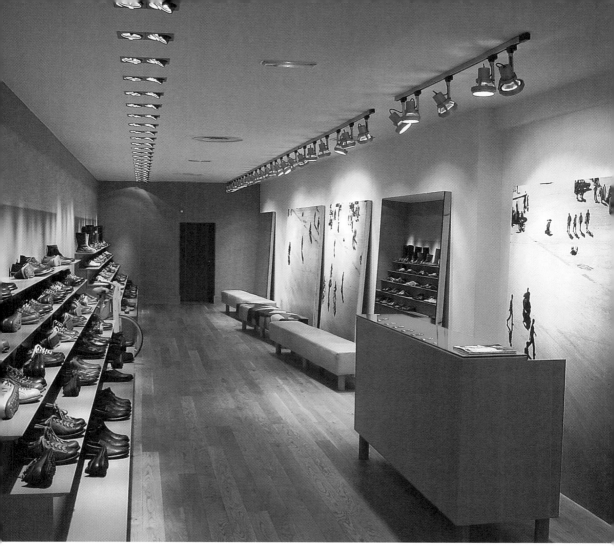

_Camper sur Calle Ayala, 13. Madrid, 2001

_Camper at Calle Ayala, 13. Madrid, 2001

_Camper auf der Calle Ayala, 13. Madrid, 2001

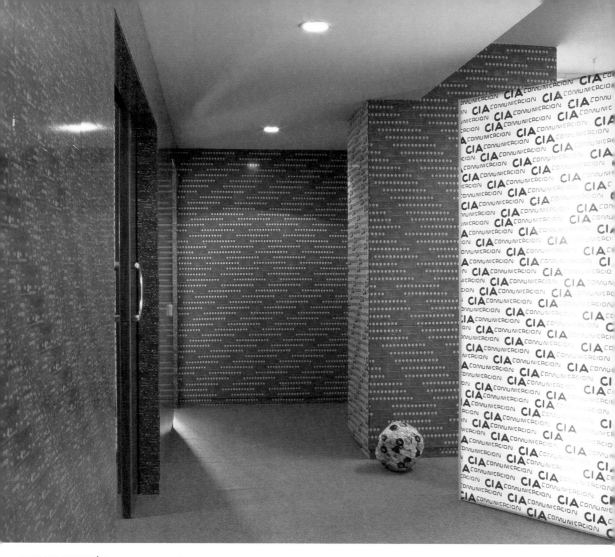

CIACOMUNICACIÓN est une agence de communication graphique de Barcelone. Mon ami Joan Armengol, qui en est l'un des fondateurs, m'a demandé de concevoir une sorte d'installation pour le hall d'entrée. J'ai proposé une performance «collage» dans laquelle tous les murs de l'agence sont couverts de ruban adhésif. Des rubans adhésifs aux fonctions diverses (pour les visiteurs, pour la détente, simulateur de plantes 1.0 et autres) font directement référence à CIACOMUNICACIÓN et à sa conception du travail d'équipe._ **CIACOMUNICACIÓN, Barcelone / Installation, 2002**

CIACOMUNICACIÓN is a graphic communication agency in Barcelona. Joan Armengol, a friend of mine who is one of the founders, requested that I do some sort of installation in the entrance way. I proposed a "Taping" action, where all the walls of the agency were covered in adhesive tape. Guest tape, relax tape, plant emulator 1.0 tape and others refer directly to CIACOMUNICACIÓN and its concept of teamwork. _CIACOMUNICACIÓN Barcelona / Installation, 2002

CIACOMUNICACIÓN ist eine Grafik-Kommunikationsagentur in Barcelona. Joan Armengol, ein Freund von mir und einer der Gründer, bat mich um eine Art Installation im Eingangsbereich. Ich schlug eine „Taping"-Aktion vor, bei der alle Wände der Agentur mit Klebeband bedeckt wurden. Guest tape, Relax tape, Plant Emulator 1.0 tape und andere Bänder beziehen sich direkt auf CIACOMUNICACIÓN und ihr Konzept von Teamarbeit. _CIACOMUNICACIÓN Barcelona / Installation, 2002

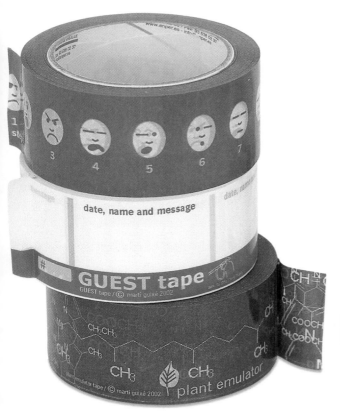

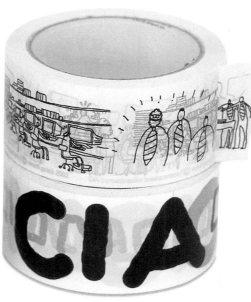

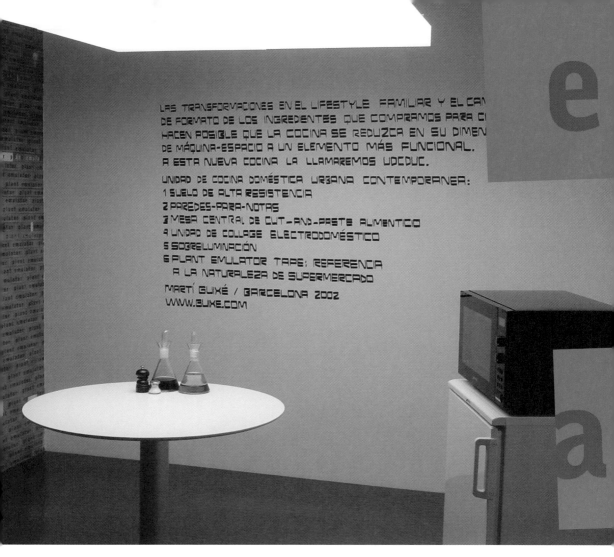

LAS TRANSFORMACIONES EN EL LIFESTYLE FAMILIAR Y EL CAM
DE FORMATO DE LOS INGREDIENTES QUE COMPRAMOS PARA C
HACEN POSIBLE QUE LA COCINA SE REDUZCA EN SU DIMEN
DE MÁQUINA-ESPACIO A UN ELEMENTO MÁS FUNCIONAL.
A ESTA NUEVA COCINA LA LLAMAREMOS UDCDUC.
UNIDAD DE COCINA DOMÉSTICA URBANA CONTEMPORÁNEA:
1 SUELO DE ALTA RESISTENCIA
2 PAREDES-PARA-NOTAS
3 MESA CENTRAL DE CUT-AND-PASTE ALIMENTICIO
4 UNIDAD DE COLLAGE ELECTRODOMÉSTICO
5 SOBREILUMINACIÓN
6 PLANT EMULATOR TAPE; REFERENCIA
 A LA NATURALEZA DE SUPERMERCADO
MARTÍ GUIXÉ / BARCELONA 2002
WWW.GUIXE.COM

Les changements survenus dans le style de vie moderne et leurs conséquences — le format nouveau des produits alimentaires et culinaires que l'on trouve sur le marché — permettent de réduire l'espace traditionnellement dédié à la cuisine. Autrefois conçue comme une «salle des machines», la cuisine peut désormais se satisfaire de dimensions moindres. On peut désigner cette cuisine par le signe UdCDUC (Unidad de Cocina Doméstica Urbana Contemporánea, unité de cuisine domestique urbaine contemporaine). Cette cuisine se compose d'une table pour les opérations «couper-coller», d'un réfrigérateur et d'une unité de cuisson (four micro-ondes et four traditionnel combinés). Il est conseillé pour les dîners de famille de faire appel aux services d'un traiteur qui livre à domicile ou d'acheter des plats pré-cuisinés. Si l'on veut apprécier

The transformations of modern lifestyle and the changing format of the ingredients we buy to cook with allow for the reduction of the space of the kitchen, once conceived as a machine-space, to a more functional dimension. This new kitchen can be termed a UdCDUC: Unidad de Cocina Doméstica Urbana Contemporánea (Contemporary Domestic Urban Kitchen Unit).
The kitchen is made up of a table for "cut and paste" operations, a refrigerator and a combo microwave unit. For family get-togethers at home it is advisable to use a catering service or pre-prepared food. For the enjoyment of gastronomy we recommend visiting fine restaurants.

Der Wandel des modernen Lebensstils und die sich verändernden Zutaten, die wir zum Kochen kaufen, ermöglichen die einst als Maschinenraum konzipierte Küche auf eine zweckmäßigere Größe zu verkleinern. Diese neue Küche lässt sich als UdCDUC bezeichnen: Unidad de Cocina Doméstica Urbana Contemporánea (Zeitgenössische häusliche, städtische Kücheneinheit). Die Küche besteht aus einem Tisch für Arbeiten wie „cut and paste", einem Kühlschrank und einer kombinierten Mikrowelleneinheit. Für Familientreffen zu Hause sind ein Partyservice oder Fertiggerichte ratsam. Zur Freude der Gastronomie empfehlen wir den Besuch vornehmer Restaurants. UdCDUC: 1. Sehr

emulator

plant

nt e mu

plant emulator tape / © martí guixé 2002 / www.guixe.com

la gastronomie fine, nous recommandons les bons restaurants. UdCDUC : 1. revêtement de sol très résistant 2. murs sur lesquels on peut prendre des notes 3. plan de travail central pour «couper et coller» les aliments 4. unité d'éléments électroménagers 5. lumière à profusion 6. ruban adhésif «simulateur de plantes»: référence à la nature du supermarché **_UdCDUC / conception et installation chez Casadecor, Barcelone, 2002**

Contemporary Domestic Urban Kitchen Unit: 1. Highly resistant flooring 2. Walls for taking notes 3. Central table for foodstuff cutting and pasting 4. Home appliance collage unit 5. Excess lighting 6. Plant Emulator tape: a reference to the nature of the supermarket **_UdCDUC / concept and installation at Casadecor, Barcelona 2002**

widerstandsfähiger Fußbodenbelag 2. Wände für Notizen 3. Zentral gelegener Tisch für „cut and paste" 4. Collage-Einheit Haushaltsgeräte 5. Übermäßige Beleuchtung 6. Plant Emulator tape: eine Anspielung auf die Natur des Supermarktes **_UdCDUC / Konzept und Installation bei Casadecor, Barcelona 2002**

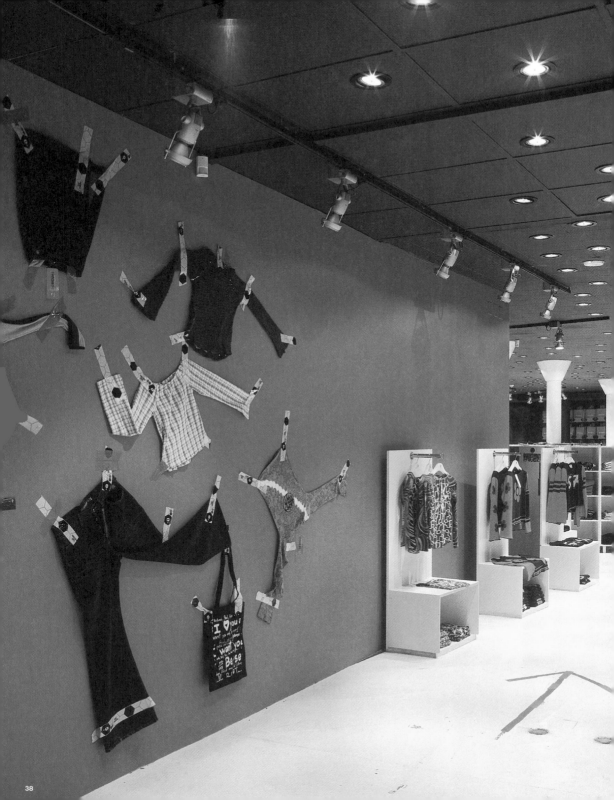

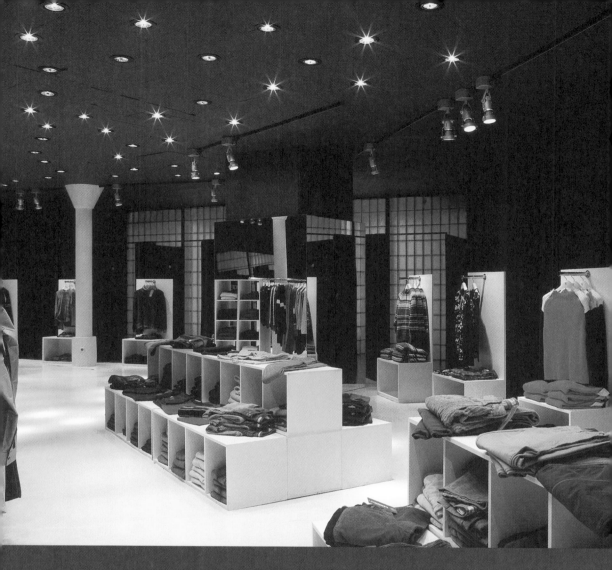

DESIGUAL SHOP / ARGENTERIA 65 / BARCELONA, 2002

_ DESIGUAL À LA SALA ZELESTE

La boutique Desigual est un établissement commercial de Barcelone. Elle occupe les locaux qui furent pendant une décennie — à partir du milieu des années 1970 — ceux de la mythique salle de concert SALA ZELESTE. La société qui lui succéda, à partir de 1986, laissa intacts divers éléments d'architecture de l'ancienne salle. Cette dernière avait dû, faute de place et à cause de relations difficiles avec le voisinage, s'installer dans un immeuble plus grand de Poble Nou. Elle a définitivement fermé ses portes en 2001.

Comme l'édifice est considéré patrimoine historique, les travaux de réhabilitation complète s'annoncent complexes et longs. Il est question de déplacer l'escalier qui obstrue l'entrée, utilisé par les occupants de l'immeuble, et d'éliminer les espaces vides de la double enceinte murale qui formait une barrière acoustique à la périphérie de la salle, ce qui entraînera la perte de quelque 0,5 m du périmètre interne.

_ L'INSTALLATION

On a, pour ces diverses raisons, envisagé de mettre en place une installation provisoire; celle-ci permettait en effet d'inaugurer la boutique quinze jours plus tard. Le problème de l'adaptation à la vocation nouvelle du lieu et la nécessité de travailler sur l'espace en termes d'installation temporaire et non sur un projet de décoration intérieure précis et définitif ont inspiré la fonctionnalité des codes et protocoles du projet. De ce fait l'intervention gagna en efficacité et le résultat fut d'une grande originalité. Néanmoins la rénovation complète reste programmée; elle demandera plus de soin et plus de temps.

_ L'EFFET COULISSES

L'installation provisoire divise la salle en deux espaces. Accessibles indépendamment l'un de l'autre, ils ont été conçus et employés différemment. L'espace central, blanc, est utilisé pour l'exposition. L'espace périphérique, bleu foncé, est conçu comme des coulisses. L'éclairage dissimule au regard l'espace périphérique qui reste néanmoins présent physiquement.

_ DESIGUAL IN ZELESTE

Desigual Shop is a commercial establishment in Barcelona. It occupies the premises where the mythical concert hall SALA ZELESTE was located for a decade, starting in the mid 1970s. Even though another business occupied the space after 1986, certain recognizable architectural elements from Zeleste remained. The concert hall left the area due to a need for more space and problems with the immediate neighbours, moving into a larger building in Poble Nou until it finally closed in 2001.

Considering the building has historical value, it will certainly be a complex and slow process to redo the space completely. The intention is to move the stairway used for the building's residents, as it obstructs the entrance, as well as eliminating the double wall spaces that served as an acoustic barrier, with the loss of almost half a metre along the interior perimeter.

_ INSTALLATION

For these reasons the idea was to carry out a provisional installation which would allow the shop to be opened in just 2 weeks. The concept of appropriation and the fact of working on the space in terms of installation and not as a full-fledged interior design have given the codes and protocols of the project a functional character, allowing the intervention to be more effective, giving it a uniquely characteristic result. The complete renovation project is slated to be done later on with greater time and care.

_ THE BACKSTAGE EFFECT

The installation divides the premises into two spaces, which in spite of being totally accessible have been conceived and employed in different ways. There is a central white space used for display and a dark blue perimeter space here conceived as the backstage. The lighting makes the perimeter space disappear even though it is physically present.

This dark space surrounding the display area is where the changing rooms are found, thus parasiting the structures of backlit glass bricks

_ DESIGUAL IN ZELESTE

Desigual Shop ist ein kommerzielles Unternehmen in Barcelona. Es befindet sich auf dem Gelände, auf dem ab Mitte der siebziger Jahre für ein Jahrzehnt die mythische Konzerthalle SALA ZELESTE stand. Auch wenn dort nach 1986 ein anderes Unternehmen die Räume belegte, sind bestimmte architektonische Elemente von Zeleste erhalten geblieben. Wegen eines höheren Raumbedarfs und Problemen mit der unmittelbaren Nachbarschaft gab die Konzerthalle das Areal auf und zog in ein größeres Gebäude in Poble Nou, bis sie 2001 schloss.

Angesichts der historischen Bedeutung des Gebäudes wird es sicherlich ein vielschichtiger und langsamer Prozess sein, den Raum gänzlich zu erneuern. Beabsichtigt ist, den von den Hausbewohnern genutzten Treppenaufgang zu entfernen, da er den Zugang zum Verkaufsraum erschwert Ebenso zu beseitigen sind die früher als Schalldämmung dienenden vorgesetzten Wände, die einen Verlust von fast einem halben Meter entlang der inneren Begrenzung darstellen.

_ INSTALLATION

Daher sollte eine provisorische Installation gemacht werden, die es ermöglichte, das Geschäft binnen nur zwei Wochen zu eröffnen. Das Nutzungskonzept und der Umstand, den Raum in Form von Installationen und nicht als eigenständige Raumgestaltung zu bearbeiten, gaben den Abläufen des Projekts einen zweckmäßigen Charakter. Dadurch konnten die Eingriffe effektiver sein und zu einem einmalig charakteristischen Ergebnis führen. Die vollständige Neugestaltung soll zu einem späteren Zeitpunkt mit mehr Zeit und Sorgfalt stattfinden.

_ DER KULISSENEFFEKT

Die Installation unterteilt die Räumlichkeiten in zwei Bereiche, die zwar zusammenhängen, aber dennoch unterschiedlich konzipiert und belegt sind. Es gibt einen zentralen weißen Raum für die Auslagen und einen umlaufenden dunkelblauen, als Kulisse gedachten Bereich. Die Beleuchtung lässt den umlaufenden Raum verschwinden, obwohl er physisch vorhanden ist.

In diesem dunklen Raum um den Auslagebereich befinden sich die Umkleidekabinen. Sie profitieren somit von den beleuchteten

C'est dans cet espace sombre à la périphérie du lieu d'exposition que se trouvent les cabines d'essayage qui viennent parasiter la paroi en briques de verre qui, avec son éclairage arrière constituait le trait distinctif de Zeleste. Ainsi l'espace commercial ne vient-il pas effleurer les murs de l'élément archéologique d'origine. Cette distribution de l'espace met en valeur de façon à la fois logique et novatrice les fonctions utilitaires de la surface commerciale. Disposés frontalement, les socles-panneaux qui séparent l'espace public de l'espace privé, confidentiel, servent de supports aux produits. A l'arrière, face aux coulisses, ces panneaux sont couverts d'étiquettes gommées illustrées, parmi lesquelles des coupures de presse de Zeleste, des photos de l'installation en cours d'aménagement et des illustrations de la marque. Lorsque le client entre dans les coulisses, ou sphère «privée», pour essayer un vêtement en cabine, une complicité subliminale s'établit entre lui et la marque, qui bénéficie par ricochet d'un statut affectif auprès de l'acheteur.

_ EFFET MAGNÉTIQUE
Le hall d'entrée est conçu comme diorama et illustration de la marque. Cette illustration est constituée par des pages de catalogue au format affiche murale et par une sélection de vêtements fixés isolément au mur à l'aide de ruban adhésif. Ces échantillons grandeur nature font du diorama une scène de théâtre et une vitrine. Cette association entre logique et affectif a pour effet d'attirer les clients dans le magasin.

_ SIGNATURES
Au fond de cet espace, dans une pièce distincte, j'utilise un film vidéo d'une durée d'une minute et demi pour inviter les acheteurs à signer une pétition: celle-ci demande le maintien en l'état de l'installation temporaire comme version définitive et permanente du lieu réhabilité.

_ **Marti Guixé, 2002**

that were a characteristic feature of Zeleste, conserving their archeology by not allowing the commercial area to touch upon the walls.
With this layout the practical functions of the commercial space are set out in a more logical and innovative manner.
The panels separating the public from the private area work frontally as display elements for the product, while their opposite side, the backstage, features discreet stickers with images, including press clips from Zeleste, images of the construction of the installation, and informal representations of the brand in question.
Upon entering into the more "private" backstage area to try on a garment, the customer comes into subliminal complicity with the brand and acquires a new emotional status with it as well.

_ THE MAGNET EFFECT
The entrance way is conceived as a diorama and map of the brand. The map is made up of a large size poster-catalogue and a selection of garments attached to the wall with adhesive tape as samples in real size, making the diorama both stage and shop window. This logical-emotional combination has a complementary function and acts in itself as a mechanism to attract and invite customers into the interior.

_ SIGNATURES
At the end of the space in a separate room, I use a video a minute and a half long to personally request that visitors sign a petition to have the temporary installation be accepted as the final, permanent version.

_ **Marti Guixé, 2002**

Glasziegelsteinen, einem typischen Merkmal von Zeleste, und erhalten deren Archäologie, weil die Wände von der Verkaufsfläche aus nicht zu berühren sind. Mit diesem Layout werden die praktischen Funktionen des Geschäfts in einer logischeren und innovativen Art angeordnet. Die Platten, die den öffentlichen vom privaten Bereich abtrennen, fungieren auf der Stirnseite als Displayelemente für die Waren, während sich ihre Rückseite, die Kulisse, durch dezente Aufkleber mit Bildern auszeichnet, darunter Presseausschnitte von Zeleste, Abbildungen vom Bau und der Installation sowie inoffizielle Darstellungen des betreffenden Labels.
Betritt der Kunde zur Anprobe eines Kleidungsstücks den eher „privaten" Bereich, gerät er in eine unterbewusste Teilhaberschaft mit dem Label und erhält außerdem in Bezug zu diesem einen neuen emotionalen Status.

_ DER MAGNETEFFEKT
Der Eingangsbereich ist als Diorama und als Landkarte der Marke konzipiert. Die Landkarte besteht aus einem großformatigen Poster-Katalog und einer Auswahl von Kleidungsstücken. Diese sind als Muster in Originalgröße an der Wand mit Klebeband befestigt und machen das Diorama sowohl zu einer Bühne als auch zu einem Schaufenster. Diese logisch-emotionale Kombination besitzt eine ergänzende Funktion und wirkt in sich als Mechanismus, um Kunden anzuziehen und in den Innenraum einzuladen.

_ UNTERSCHRIFTEN
Am Ende des Raumes in einem gesonderten Zimmer ersuche ich in einem eineinhalb Minuten langen Video die Besucher persönlich, eine Petition zu unterschreiben, die temporäre Installation als letzte, ständige Version zu akzeptieren.

_ **Marti Guixé, 2002**

Urban post-it est un élément fonctionnel au langage non architecturé. Son installation est parasite; il est par nature provisoire et échappe aux normes de l'urbanisme. _**Urban Post-it / Pièce unique, 100 x 80 cm. 1999**

Urban post-it is a functional element with a non-architectural language, installed in parasitic form; it is provisional, enabling it to evade urban planning norms. _**Urban Post-it / Piece, 100 x 80 cm. 1999**

Urban post-it ist ein nicht-architektonisches Element, das parasitär installiert werden kann; es ist provisorisch und ermöglicht, die städtebaulichen Vorschriften zu umgehen. _**Urban Post-it / Werk, 100 x 80 cm. 1999**

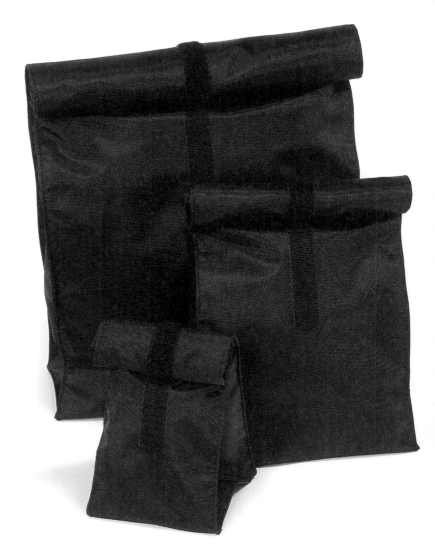

Sacs multi-usage à fermeture en velcro: leur taille s'adapte au contenu. Trois dimensions, couleurs variées. _**Easy Bags / Produits par Authentics, 2000**

Multi-use bags with a Velcro closure system, able to be altered in size according to content. 3 sizes, various colours. _**Easy Bags / Produced by Authentics, 2000**

Mehrfach zu nutzende Taschen mit einem Klettbandverschluss, Größe veränderbar je nach Inhalt. Drei Größen, verschiedene Farben. _**Easy Bags / Hergestellt von Authentics, 2000**

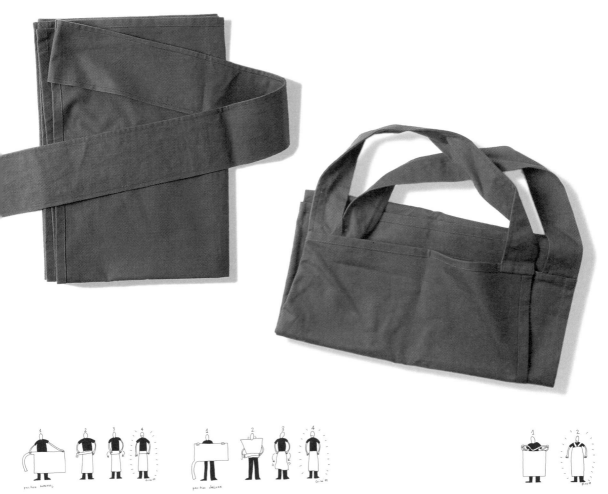

Ces tabliers fonctionnels et torchons de cuisine sont plus simples que les tabliers traditionnels. Le minimalisme des accessoires est garant d'une longévité accrue et les rend plus contemporains. _Authentics Aprons: tablier, tablier long, torchon / Produits par Authentics, 2000

These aprons retain functionality with fewer elements, their simplification prolonging their lives and making them more contemporary. _Authentics Aprons: apron, long apron, towel / Produced by Authentics, 2000

Diese Schürzen bestehen aus wenigen Elementen und bewahren die Funktionalität. _Authentics Aprons Schürze, lange Schürze, Küchenhandtuch / Hergestellt von Authentics, 2000

Pictogrammes désinvoltes pour signalétique standard. Sur l'un des pictogrammes on peut écrire un message entier. _**Authentics Sign Collection, 7 dessins / Produit par Authentics, 2002**

Casual pictograms for standard signage. One of the pictograms allows you to write in whatever you wish to communicate. _**Authentics Sign Collection, 7 signs / Produced by Authentics, 2002**

Unbestimmte Piktogramme für Standardkennzeichnungen. Eines der Piktogramme gestattet, jede gewünschte Mitteilung hineinzuschreiben. _Authentics Sign Collection, 7 Zeichen / Hergestellt von Authentics, 2002

BUY GUIXÉ

J'ai réalisé qu'il n'y a pas dans mon œuvre de différentiation très nette entre ce qui est produit en exemplaires multiples et ce qui est pièce unique, prototype, projet ou concept. C'est pourquoi j'ai créé une boutique online où, au lieu de vendre directement, je dirige les personnes intéressées par mes productions au moyen de liens vers les sites où elles peuvent acheter les articles qui ont été réalisés en série.
_www.buyguixe.com / Projet, 2003 / En collaboration avec Hans Bernhard (übermorgen)

I have realized that there is not a very clear differentiation in my work between what is produced and what is a single piece, a prototype, a project or a concept.
For this reason I have set up an online shop where instead of selling directly I redirect those interested through links to where they can purchase the products that have been produced. _www.buyguixe.com / Project, 2003 / In collaboration with Hans Bernhard (übermorgen)

Ich habe festgestellt, dass es in meiner Arbeit keine sehr klare Unterscheidung gibt zwischen dem, was produziert ist und dem, was ein Einzelstück, einen Prototyp, ein Projekt oder ein Konzept darstellt. Aus diesem Grunde habe ich ein Online-Geschäft eröffnet, bei dem ich statt direkt zu verkaufen, die Interessenten über Links dahin weiterleite, wo sie die produzierten Erzeugnisse erwerben können.
_www.buyguixe.com / Projekt, 2003 / In Zusammenarbeit mit Hans Bernhard (übermorgen)

MARTÍ GUIXÉ

Brilliantly simple and curiously serious

EXHIBITIONS
INTERIORS
PROJECTS
SHOP/PRODUCTS

The Unconventional Gaze: Martí Guixé [Techno-gastrosof, Tapaist, Designer]

ABOUT
PRESS
FAN CLUB
CONTACT

Pendant des années j'ai programmé mes pages web en html; je les enregistrais en Word. Puis, un jour, la technologie m'a dépassé. Comme je n'avais plus le temps de rattraper la technologie, le moment était venu pour moi de rédiger directement, à la main, la page d'accueil de mon site. _www.guixe.com / Projet, 2003 / En collaboration avec Hans Bernhard (übermorgen)

For years I programmed by webpage with html, typing in Word, until the technology got beyond me and I ran out of time. The moment has come to write up the webpage directly by hand. _www.guixe.com / Project, 2003 / In collaboration with Hans Bernhard (übermorgen)

Jahrelang programmierte ich meine Homepage mit html unter Verwendung von Word bis mich die Technik einholte und ich keine Zeit mehr hatte. Es ist der Augenblick gekommen, die Homepage unmittelbar von Hand weiterzuführen. _www.guixe.com / Projekt, 2003 / In Zusammenarbeit mit Hans Bernhard (übermorgen)

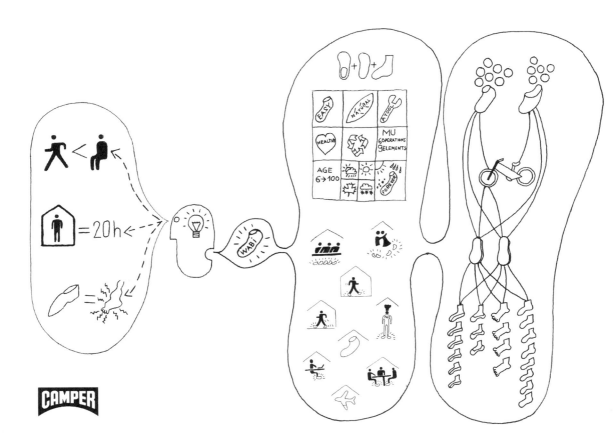

La tâche consistait ici à faire passer intégralement la philosophie, la fonction et le catalogue de la ligne Camper Wabi sans — dans la mesure du possible — utiliser de mots. J'ai commencé par proposer la présentation de toute l'information dans une chaussure, sur une brochure pliée, ayant la forme même d'une chaussure. _**Camper Communication – la ligne Wabi / Projet, 2000**

The commission was to transmit the entire philosophy, function and catalogue of the Camper Wabi line without the use of words, as much as could be possible. Initially I proposed presenting all the information inside a shoe on a brochure folded into the shape of a shoe. _**Wabi communication for Camper / Project, 2000**

Der Auftrag lautete, die gesamte Philosophie, Funktion und den Katalog der Camper Wabi-Linie soweit wie möglich ohne Verwendung von Wörtern zu vermitteln. Zuerst schlug ich vor, alle Informationen in einem Schuh auf einem zu einer Schuhform gefalteten Prospekt zu geben. _ **Wabi Kommunikation für Camper / Projekt, 2000**

SI SUZANNE AVAIT ACHETÉ LE RIDEAU DE DOUCHE DE GUIXÉ ELLE AURAIT VU VENIR LES VIEILLARDS.

J'écris ce texte, bien au chaud dans mon bain ylang ylang et protégée par mon nouveau Panoptical Bath Curtain, sur la tablette un thé citron, et en mémoire deux livres: *Surveiller et punir* de Foucault et *1984* d'Orwell. Ils m'ont appris que la notion de vision panoptique est reliée à des principes de non-liberté, d'enfermement, de surveillance et de châtiment. Je sais que je me dois de contrôler le contrôle de mon intérieur et qu'aucun contrat d'assurance ne me protègera de mes peurs et de mes petites paranoïas. Alors là, trempant dans mon jus, je crois être libre dans ma salle de bain, personne ne me voit et de plus je peux voir sans être vue, garde-chiourme de mon intimité, grâce à ce rideau de douche et son judas intégré. Je me dis que si j'inverse le rideau je crée une cabine de peep-show et là soudain la peur surgit: je pense à *Psychose* où Anthony Perkins poignarde une femme à travers un rideau de douche. Je suis convaincue que cette scène tétanisa aussi des milliers de femmes qui après ce film ne se douchèrent plus comme

IF SUSANNAH HAD BOUGHT GUIXÉ'S SHOWER CURTAIN, SHE WOULD HAVE SEEN THE ELDERS COMING.

I am writing this text lying nice and warm in my ylang ylang bath, protected by my new Panoptical Bath Curtain, with a lemon tea in hand and two books in my mind: Foucault's *Surveiller et punir (Discipline and Punish)* and Orwell's *1984*. It was they that taught me that the concept of panoptical vision is related to principles of lack of freedom, of confinement, surveillance and punishment. I know that I owe it to myself to monitor the monitoring of the inside of my home and that no insurance policy will protect me from my fears and my small paranoias. So, soaking in my bath, I believe I am free in my bathroom. Nobody sees me and, what is more, I can see without being seen, warder of my privacy, thanks to this shower curtain and its integral spy-hole. I tell myself that if I reverse the curtain I will create a peep-show cubicle, and all of a sudden the fear comes: I am thinking of *Psycho*, in which Anthony Perkins stabs a woman through a shower curtain. I am convinced this scene also petrified the thousands of women who never felt the same way again

WENN SUSANNE DEN DUSCHVORHANG VON GUIXÉ GEKAUFT HÄTTE, DANN HÄTTE SIE DIE ALTEN KOMMEN SEHEN.

Ich schreibe diesen Text in meinem wohlig warmen Ylang-Ylang-Bad liegend, geschützt von meinem neuen Panoptical Bath Curtain, auf der Ablage einen Zitronentee und im Gedächtnis zwei Bücher: *Überwachen und Strafen* von Foucault und *1984* von Orwell. Diese haben mich gelehrt, dass der Begriff der panoptischen Sicht mit den Prinzipien der Nicht-Freiheit, des Gefangenseins, der Überwachung und der Bestrafung zusammenhängt. Ich weiß, dass ich, über mein Zuhause wachen muss und dass mich keine Versicherung vor Ängsten und kleinen Wahnvorstellungen schützt. Also, in mein Bad eingetaucht, glaube ich, in meinem Badezimmer frei zu sein; niemand kann mich sehen, aber ich kann sehen, ohne gesehen zu werden, Gefängniswärterin meiner Intimsphäre, dank dieses Duschvorhangs und seinem integrierten Guckloch. Würde ich den Vorhang wenden, wäre es eine Peepshow-Kabine. Und plötzlich taucht da die Angst auf: Ich denke an Psycho, in dem Anthony Perkins eine Frau durch einen Duschvorhang erdolcht. Ich bin davon überzeugt, dass diese Szene Tausende von Frauen erstarren ließ, die nach diesem Film nicht mehr so duschten wie zuvor,

avant, même si en tant que cinéphile je sais que c'est la main d'Hitchcock qui traverse la toile de l'écran et qui tient le couteau qui nous poignarde nous spectateurs. Le design de Martí Guixé a toujours eu ce pouvoir fictionnel. Un penseur d'objets comme lui peut comme un metteur en scène nous aider à faire basculer le réel et à passer au travers du miroir. J'ai en mémoire un miroir pour salle de bain qu'il a créé, où l'image corporelle renvoyée est non indemne, fragmentée, ressemblant plus à la représentation mentale que nous nous faisons de notre propre corps qui est une sorte de copier-coller qu'au face-profil-dos que nous renvoie un miroir habituel. Je dois vite sortir de mon bain, quelqu'un m'appelle à la porte d'entrée, je vous conseille la Doorbell de Guixé, une de ses dernières productions, on se croirait au bon temps de la Barcelone où pour se faire ouvrir on criait le nom dans la rue ou l'on frappait un nombre de coups correspondant à l'étage suivi de petits coups pour indiquer gauche ou droite sur le palier. Il n'y a qu'un ex-designer comme Guixé pour nous aider à sortir de l'enfermement domotique et de l'enrobage du décor. Entourons nos corps d'objets qui soutiennent la pensée comme ce rideau et son clin d'oeil. _Brigitte Rambaud

while standing under the shower, even if, as a film enthusiast, I know that it is Hitchcock's hand that comes through the fabric of the screen and holds the knife that stabs us, the audience. Martí Guixé's design work has always had this fictive power. Someone who thinks up objects like he does can help us – like a film director – to topple reality and pass through the mirror. I am reminded of a bathroom mirror he created, in which the body image reflected is not unaffected; it is fragmented, resembling the mental representation we conceive of our own body, a sort of spliced duplicate, rather than the face–profile–back actually reflected by an ordinary mirror. I have to get out of my bath quickly; somebody is calling me at the front door. I recommend Guixé's Doorbell, one of his latest productions. One could believe oneself back in the good old days in Barcelona where, to gain admittance, you had to shout the name from the street or knock a number of times for the floor you wanted, followed by lighter knocks to indicate left or right on the landing. Only an ex-designer like Guixé can help us emerge from the confinement of the home and the wrappings of our décor. Let us surround our bodies with objects that promote thought, such as this curtain and its "wink". _Brigitte Rambaud

selbst wenn ich als Kinofan weiß, dass es die Hand von Hitchcock ist, die durch die Leinwand kommt und das Messer hält, das uns, die Zuschauer, erdolcht. Martí Guixés Gestaltungen haben stets diese fiktive Kraft. Da er sich Objekte ausdenkt, kann er uns wie ein Regisseur helfen, die Wirklichkeit ins Wanken zu bringen. Ich erinnere mich an einen von ihm geschaffenen Badezimmerspiegel, bei dem das reflektierte Körperbild nicht unversehrt ist. Es ist zerbrochen und ähnelt mehr dem geistigen Bild, das wir uns von unserem eigenen Körper machen, der eher eine Art geklebte Kopie ist als die von einem gebräuchlichen Spiegel reflektierte Gesicht-Profil-Rücken-Ansicht. Ich muss schnell aus meinem Bad steigen, weil mich jemand an die Eingangstür ruft. Ich empfehle Guixés Doorbell, eine seiner jüngsten Produktionen. Man könnte sich in die guten alten Tage in Barcelona versetzt fühlen, wo man, um Einlass zu bekommen, den Namen von der Straße aus rief oder die dem Stockwerk entsprechende Zahl klopfte, gefolgt von kleinen Schlägen, um links oder rechts des Treppenabsatzes anzugeben. Nur ein Ex-Designer wie Guixé kann uns helfen, das häusliche Gefangensein und die Umhüllungen des Dekors zu überwinden. Umgeben wir unsere Körper mit Objekten, die unsere Gedanken fördern, so wie dieser Vorhang und sein „Augenzwinkern". _Brigitte Rambaud.

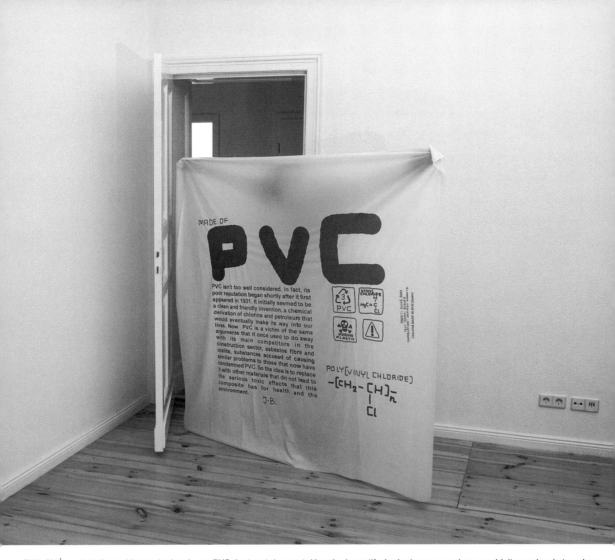

MADE OF
PVC

PVC isn't too well considered. In fact, its poor reputation began shortly after it first appeared in 1931. It initially seemed to be a clean and friendly invention, a chemical derivation of chlorine and petroleum that would eventually make its way into our lives. Now PVC is a victim of the same arguments that it once used to do away with its main competitors in the construction sector, asbestos fibre and uralite, substances accused of causing similar problems to those that now have condemned PVC. So the idea is to replace it with other materials that do not lead to the serious toxic effects that this composite has for health and the environment. J.B.

POLY(VINYL CHLORIDE)
$$-[CH_2-CH]_n-$$
$$| $$
$$Cl$$

CHA-CHÁ produit divers rideaux de douche en PVC dont certains sont décorés de motifs écologiques, ce qui me semblait paradoxal et quelque peu suspect. Le concept du «rideau en PVC» est de mettre en évidence cette contradiction manifeste dans le rideau produit et son illustration dans le catalogue de la société. _PVC Curtain / **Produit par CHA-CHÁ, 2002**

CHA-CHÁ makes various PVC bath curtains, some of them decorated with ecological motifs, which seemed to me to be paradoxical and somewhat questionable. The idea of the "PVC Curtain" is that once it is produced and appears in the company catalogue, this point of tension might be made evident. _PVC Curtain / **Produced by CHA-CHÁ, 2002**

CHA-CHÁ stellt verschiedene PVC-Duschvorhänge her, von denen manche mit Öko-Motiven verziert sind – was mir paradox und etwas zweifelhaft vorkam. Dem „PVC-Vorhang" liegt die Idee zugrunde, dass auf diesen spannenden Punkt aufmerksam gemacht werden könnte, sobald er produziert worden ist und Bestandteil des Produktkatalogs geworden ist. _PVC Curtain / **Hergestellt von CHA-CHÁ, 2002**

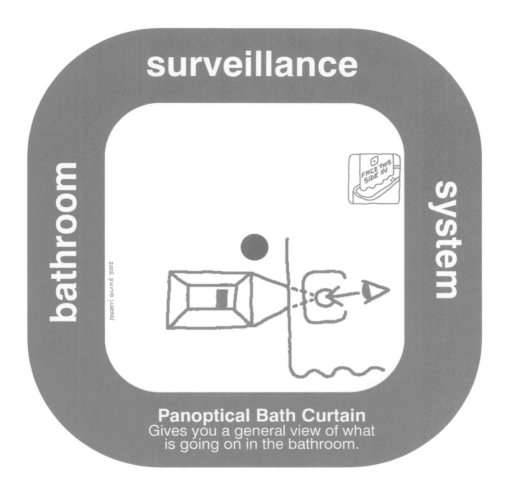

Panoptical Bath Curtain
Gives you a general view of what is going on in the bathroom.

Un rideau de douche présentant une perforation en son centre permet de surveiller ce qui se passe dans la salle de bain et retourne le cliché du voyeur observant la personne se douchant, car c'est celle-ci qui contrôle alors l'espace depuis la perforation dans le rideau de plastique. _Panoptical Bath Curtain / Produit par CHA-CHÁ, 2002

A bath curtain with a perforation in the centre allows for the visual control of what is going on in the bathroom, thus subverting the cliché of the hole used to spy on the person showering, as it is this latter who controls the space. _Panoptical Bath Curtain / Produced by CHA-CHÁ, 2002

Ein Duschvorhang mit einem Loch in der Mitte ermöglicht, das Geschehen im Badezimmer zu überwachen. Damit wird das Klischee von dem Loch untergraben, durch das man auf die duschende Person spähen kann, da letztere die Kontrolle über den Raum hat. _Panoptical Bath Curtain / Hergestellt von CHA-CHÁ, 2002

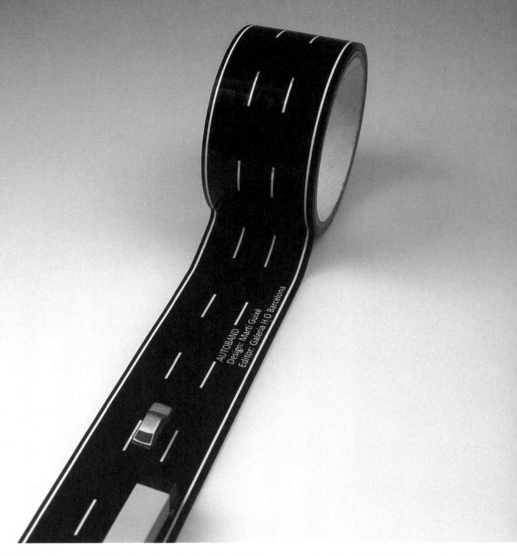

AUTOBAND
Design: Martí Guixé
Editor: Galeria H O Barcelona

3 de mes rubans adhésifs classiques. L'adhésif autoroute a vu le jour à la suite d'une commande de jouet de l'architecte Joaquim Ruiz Millet (Galeria H$_2$O). L'inspiration m'est venue de la fascination qu'exerçait sur moi le premier tronçon expérimental de l'AVUS (Automobil-Verkehrs-und Uebungsstrecke), que j'avais fréquemment emprunté dans mes allers-retours à Berlin.

3 of my classic adhesive tapes. I did Autoband in reaction to a commission from the architect Joaquim Ruiz Millet (Galeria H$_2$O) to make a toy. Fascinated as I was with the idea that the first experimental length of motorway is the AVUS (Automobil-Verkehrs-und Uebungsstrecke) which I had frequently travelled on in my comings and goings from Berlin, I made the tape.

Drei meiner klassischen Klebebänder. Autoband entstand als Antwort auf einen Auftrag des Architekten Joaquim Ruiz Millet (Galeria H$_2$O), ein Spielzeug herzustellen. Ich fertigte das Band, weil ich von der Idee fasziniert war, dass die erste Autobahnversuchsstrecke die AVUS (Automobil-Verkehrs-und Übungsstrecke) ist, auf der ich von und nach Berlin häufig gefahren war.

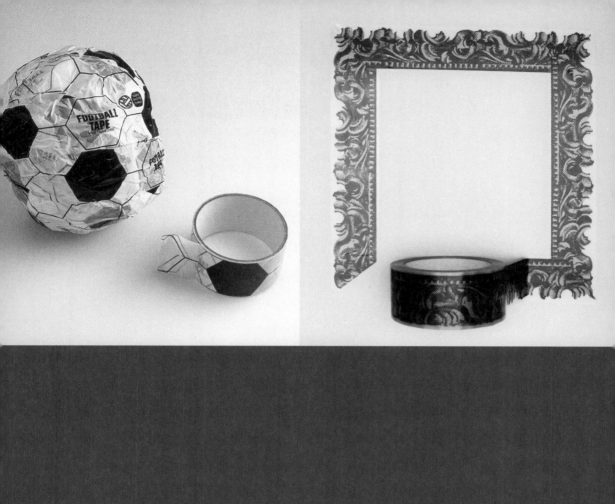

L'adhésif football fut créé pour la Biennale de Saint-Etienne, ville qui se flatte de posséder l'équipe de football la plus populaire de France («Les Verts»). C'était ma manière de rendre hommage à la ville et ce fut peut-être de toute la Biennale la seule pièce qui fit référence à Saint Etienne. Do Frame — adhésif d'encadrement — est un ruban adhésif qui permet à chacun de créer quelque chose d'aussi contemporain que de réaliser son propre musée. _Autoband Tape / Produit par Galeria H$_2$O, 1998 / Football Tape, 2000 / Production personnelle, hors commerce / Do Frame / Produit par do, 2000

Football tape was made for the Saint-Etienne Biennale, knowing that the team in the city is one of the most popular in France (Les Verts). In this case it was my reference to the city, and was possibly as well the only piece in the entire Biennale with a reference to Saint-Etienne. Do Frame is a tape that makes it possible to do something as contemporary as allowing each individual to develop his or her own museum. _Autoband tape / Produced by Galeria H$_2$O, 1998 / Football Tape, 2000 / Self-production, not for sale / Do Frame / Produced by do, 2000

Football tape machte ich für die Saint-Etienne Biennale im Wissen, dass das Team der Stadt eines der beliebtesten in Frankreich ist (Les Verts). In diesem Fall war es meine Anspielung auf die Stadt und möglicherweise auch das einzige Stück in der gesamten Biennale mit einem Bezug zu Saint-Etienne.
Das Band Do Frame ermöglicht jedem Individuum etwas so zeitgenössisches, wie ein eigenes Museum zu entwickeln. _Autoband tape / Hergestellt von Galeria H$_2$O, 1998 / Football tape, 2000 / Eigenproduktion, unverkäuflich / Do Frame / Hergestellt von do, 2000

Exposition organisée à Milan, pendant le Salon du Meuble, dans le contexte des manifestations off. L'idée était de transformer les murs de la galerie en objets au moyen d'une installation utilisant divers rubans adhésifs, dotés chacun d'une fonction spécifique, concrète, sur tout le périmètre de la galerie. Un espace totalement insolite a été de la sorte aménagé pendant la période du Salon: le lieu était vide au centre et les objets repoussés à la périphérie.

An exhibition in Milan during the "salone del mobile" (furniture show) within the context of the "fuori-salone" (off show). The idea was to turn the gallery walls into objects by means of the installation of a sequence of various adhesive tapes with a concrete function all along the perimeter. In this way a totally unusual space was created during the "salone", a space without objects in the centre but pushed out to the periphery.

Eine Ausstellung in Mailand während des „salone del mobile" (Möbelmesse) im Rahmen des „fuori-salone" (außerhalb der Messe). Die Idee war, die Wände der Galerie in Objekte zu verwandeln, indem eine Serie verschiedener Klebebänder mit konkreter Funktion entlang aller Wände installiert wurde. Auf diese Weise entstand während des „salone" ein gänzlich ungewöhnlicher Raum, ein Raum, dessen Objekte nicht in der Mitte, sondern an die Peripherie gedrängt waren.

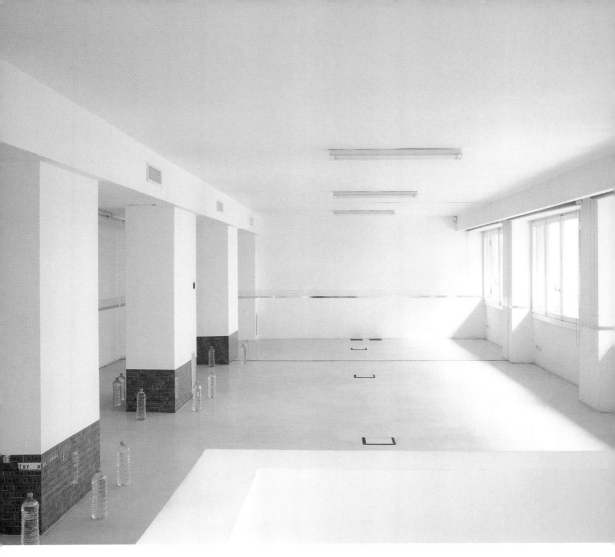

Lors de l'inauguration, il y a eu des parties de football engagées avec les visiteurs qui utilisaient le Football Tape. _1:1, Guixé, Lima, Milano / **Installation et performance / Spazio Lima, Milan, 2003**

During the opening there were football games with the visitors, using the Football Tape. _1:1, Guixé, Lima, Milano / Installation and performance / **Spazio Lima, Milan, 2003**

Zur Eröffnung fanden Fußballspiele mit den Besuchern statt, bei denen das Football tape zum Einsatz kam. _1:1, Guixé, Lima, Milano / **Installation und Performance / Spazio Lima, Mailand, 2003**

Bien que la mode ait déjà intégré ce moyen de personnalisation, cette dernière vise davantage la décoration que la fonctionnalité. Les Trico t-shirts cherchent à accentuer et consolider leur propre fonction de communication par un système qui permette au message d'être adapté à l'acquéreur. _Screaming t-shirt / Speaking t-shirt / Thinking t-shirt / Produits par Trico, 2002

Although fashion has already incorporated this means of customisation, it is always done with a decorative idea in mind, not a functional one. The Trico t-shirts seek to accent and strengthen their own communicative function with a system that allows the message to be customised. _Screaming t-shirt / Speaking t-shirt / Thinking t-shirt / Produced by Trico, 2002

Obwohl die Mode dieses Mittel der Anpassung an Kundenwünsche bereits verinnerlicht hat, geschieht dies häufig mit einer schmückenden Idee und nicht mit einer zweckmäßigen. Die Trico-T-Shirts zielen darauf ab, ihre eigene kommunikative Funktion zu akzentuieren und zu verstärken mit einem System, das eine kundenspezifische Botschaft ermöglicht. _Screaming t-shirt / Speaking t-shirt / Thinking t-shirt / Hergestellt von Trico, 2002

Ce mécanisme est une sorte d'aide pour le visiteur qui sonne à la porte. Existe en trois formats dont un modèle avec appel personnalisé: vous criez le nom de la personne que vous cherchez en frappant à la porte. _**Human Door Bells / Produit par CHA-CHÁ, 2003**

This is a mechanism to aid in calling at a door, a type of door knocking assistant. 3 sizes, and one with customised shouting: you shout for the person you are looking for while knocking on their name. _**Human Door Bells / Produced by CHA-CHÁ, 2003**

Dies ist ein Mechanismus, der dabei behilflich ist, jemanden an die Tür zu rufen, eine Art Assistent zum Anklopfen. Drei Größen, eine mit kundenspezifischem lautem Ruf: Man ruft nach der gesuchten Person, solange man auf ihren Namen klopft. _**Human Door Bells / Hergestellt von CHA-CHÁ, 2003**

COMMENT DEVENIR UN HABITANT DE GUIXÉLAND : UNE UTOPIE ATTÉNUÉE

La publication récente de *1:1 Martí Guixé*[1], qui présente pour la première fois l'ensemble des travaux exécutés par Guixé entre 1997 et 2001, illustre la profonde cohérence de l'œuvre depuis ses débuts. Malgré la diversité des contextes historico-biographiques, la diversité des commandes et des budgets alloués, le statut chaque fois différent des commanditaires et clients, les travaux de Guixé constituent une œuvre dont l'unité interne est telle qu'elle peut être considérée comme un *objet distribué*. Ou, si l'on reprend la définition d'Alfred Gell: «un objet constitué de nombreux éléments séparés dans l'espace, chacun d'entre eux doté de micro-antécédents différents»[2]. En raison de l'expansion et de la distribution de cette pièce unique dans l'espace, on pourrait être tenté de concevoir la totalité d'une vie quotidienne dans un environnement exclusivement Guixé. La description des effets produits par cet univers utopique, créé de toutes pièces — appelons-le *Guixéland* — sur ses habitants sera présentée dans les grandes lignes. Ceci nous évitera de devoir examiner les raisons profondes de la stratégie insolite qui est

BECOMING A GUIXÉLANDER: A UTOPIAN UNDERSTATEMENT

The recent publication of *1:1 Martí Guixé*[1], the first collection of Guixé's complete works covering 1997 to 2001, stresses the intense sense of coherence that has guided the development of his pursuits. Despite different historical-biographical contexts, diverse conditions of briefs and budgets, and the varied status of the commissioners and clients, Guixé's works make up an œuvre with enough internal unity to be considered a single *distributed object*; that is, using Alfred Gell's definition, "an object having many spatially separated parts with different microhistories"[2]. Due to the wide ground covered by this distributed object one could be tempted to conceive of the possibility of an entire everyday life spent in an absolute Guixé environment. The description of some of the effects of this constructed, bogus world — let us call it *Guixéland* — over its inhabitants will be outlined as a way to avoid having to scrutinise the principles that underlie the particular course that the construction of this world has taken.[3]

Let us begin by putting on a full-length Guixé apron. We feel reassured by the quality of the fabric, the elegance of

EIN GUIXÉLÄNDER WERDEN: EIN UTOPISCHES UNDERSTATEMENT

Die Veröffentlichung von *1:1 Martí Guixé*[1], der ersten vollständigen Zusammenstellung der Werke Guixés von 1997 bis 2001, verdeutlicht den enormen Sinn für Kohärenz, welcher die Entwicklung seiner Arbeit bestimmt. Ungeachtet der verschiedenen historisch-biografischen Kontexte, der vielfältigen Auftrags- und Budgetbedingungen und der unterschiedlichen Stellung von Beauftragten und Kunden bilden Guixés Werke ein Œuvre mit genügend innerer Einheit, um als ein einziges verbreitetes Objekt zu gelten, das heißt nach Alfred Gells Definition: als „Objekt, das viele räumlich voneinander getrennte Teile mit diversen Mikro-Geschichten hat"[2]. Weil dieses verbreitete Objekt ein weites Feld abdeckt, könnte man versucht sein, sich den gesamten Alltag in einer vollständigen Guixé-Umgebung vorzustellen. Die Beschreibung einiger Auswirkungen dieser konstruierten Scheinwelt — nennen wir sie *Guixéland* — auf ihre Bewohner wird sich als Weg abzeichnen, um eine genaue Untersuchung jener Prinzipien zu vermeiden, denen der besondere Verlauf des Aufbaus dieser Welt unterliegt.[3]

Ziehen wir zunächst einmal eine bodenlange Guixé-Schürze an. Wir fühlen uns sicher durch die Stoffqualität, den

clandestinement à l'œuvre dans la construction de ce monde[3].

Mais commençons par revêtir le long tablier de cuisine de Guixé. Nous sommes rassurés par la qualité de l'étoffe, l'élégance de la coupe et la couleur bleu foncé adaptée. C'est un tablier qui convient vraiment bien à la configuration humaine; il donne à celui qui le porte suffisamment de dignité pour le dispenser de devoir l'ôter si, à l'improviste, on venait sonner à sa porte. D'autre part, la géométrie particulière des bretelles permet de porter le tablier sans avoir à le fixer de toute autre manière. Tout se passe très bien, sauf si l'on relâche les épaules, car le tablier devient aussitôt flottant et l'on est alors, pour la bonne forme, tenu de se redresser. Cette souplesse du tablier est la garantie d'une bonne tenue permanente. Il contraint de garder le dos droit. Si l'on utilise la distinction qu'établit Michael Schiffer[4] entre les différents types de fonction de la culture matérielle, il est permis de considérer que, dans le cas du tablier, ce qui semble être une défection de la fonction utilitaire (*technofunction*) est en réalité la porte ouverte aux manifestations du comportement social (*sociofunction*). La bonne position à laquelle contraint le tablier n'est

the cut and the suitableness of the dark blue colour. An apron that really fits well, that allows you enough dignity to avoid having to take it off if someone unexpectedly knocks at your door. On the other hand, the special geometry of the straps allows you to wear it without having to tie it around your body. Everything goes well unless you relax your shoulders; then it slightly loosens and you are compelled to push your shoulders back again. The apron's looseness makes sure that you will never lose your composure; it obliges you to always have a straight back. Using the Michael Schiffer[4] distinction between the different types of function in material culture, we can consider that, in the case of the apron, what seems to be a breakdown of the utilitarian function of the thing (technofunction) is actually an open door to the manifestation of social facts (sociofunction). The good posture forced on us by the apron is not a result of an ergonomic study to improve people's efficiency, but a sign of status. This is an apron to be worn by the chef, not by the scullion. Is it possible to make a soup maintaining the arrogant stances imposed by the apron? If we consider that making soup involves bringing a few cups of water to boil, chopping, slicing or dicing

eleganten Schnitt und die angemessene dunkelblaue Farbe. Diese Schürze sitzt wirklich gut und vermittelt genügend Würde, um sie nicht ausziehen zu müssen, wenn jemand unerwartet anklopft. Wegen der besonderen Geometrie der Träger kann sie auch getragen werden, ohne sie um den Körper zu binden. Alles geht gut, bis man die Schultern entspannt; dann lockert sie sich ein wenig und man ist gezwungen, die Schultern wieder nach hinten zu drücken. Die Lockerheit der Schürze stellt sicher, dass man niemals die Fassung verliert; sie zwingt stets zu einem geraden Rücken. Mit Michael Schiffers[4] Unterscheidung zwischen den verschiedenen Funktionstypen in der Materialkultur lässt sich annehmen, dass im Fall der Schürze das scheinbare Versagen der praktischen Funktion der Sache (Technofunktion) in Wirklichkeit eine offene Tür für die Manifestation sozialer Tatsachen (Soziofunktion) ist. Die uns von der Schürze aufgezwungene gute Haltung ist nicht das Ergebnis einer ergonomischen Studie zur Verbesserung der menschlichen Leistungsfähigkeit, sondern ein Zeichen für den Status. Diese Schürze soll der Chef und nicht der Küchenjunge tragen. Kann man eine Suppe kochen und dabei die von der Schürze erzwungene arrogante Haltung beibehalten? Wenn man bedenkt, dass zum Zubereiten einer Suppe

pas le résultat d'une étude ergonomique visant à améliorer l'efficience des gestes, elle est le signe d'un statut social. C'est là un tablier que doit porter le chef, non le marmiton. Est-il possible de préparer une soupe en conservant l'attitude collet-monté qu'impose le tablier? Si faire une soupe suppose que l'on porte quelques rations d'eau à ébullition, que l'on hache menu, coupe en rondelles ou en dés les ingrédients appropriés pour les plonger dans la marmite au moment voulu, pour ensuite contrôler la température de cuisson pendant toute la durée de l'opération, l'attitude rigide imposée par le tablier paraîtra plus incommode que dédaigneuse. Mais l'exécution d'une telle séquence de gestes est-elle bien ce que l'on entend lorsqu'on dit: «le chef a créé une nouvelle soupe»?

Le sens du mot «création» — lorsqu'on se réfère au rôle du chef dans l'élaboration d'une soupe — est à l'évidence différent du simple travail manuel à la cuisine. C'est en somme ce que dit Joseph Margolis lorsqu'il remaque que Picasso créa, avec *Les Demoiselles d'Avignon*, une nouvelle forme de peinture écrivant en substance: «le peintre n'aurait pu réaliser cet exploit uniquement avec de la peinture à l'huile»[5]. En conséquence, si le tablier de Guixé peut

the appropriate ingredients, adding them to the pot at the suitable moment, and controlling the heat during the whole process, then perhaps our stances will seem rather toffee-nosed and impractical. But is carrying out such a series of actions what we imagine when we say "the chef has created a new soup"?

Certainly, the meaning of "creation" when referring to the chef's role in the making of soup is obviously different from mere manual work in the kitchen. It is much the same as Joseph Margolis' remark that Picasso created a new kind of painting in making *Les Demoiselles d'Avignon*, observing that "it would appear that he could not have done so by *using oils*"[5]. Therefore, if the Guixé apron can be considered a chef's apron, it is not only as an arbitrarily chosen status symbol (like, for instance, the king's crown), but because it is also an object that embodies the ontological peculiarity that the work of its user produces. Relevant recipes, art works or design projects are, according to Margolis, "culturally emergent entities, tokens-of-a-type that exist embodied in physical objects"[6]. Their creators, at the same time, stir physical ingredients to make a particular token of a soup, painting or apron, manipulating

gehört, mehrere Tassen Wasser zum Kochen zu bringen, die passenden Zutaten zu hacken, in Scheiben oder Würfel zu schneiden, sie im richtigen Moment in den Topf zu geben und die Hitze während des gesamten Prozesses zu überwachen, dann wirkt vielleicht unsere Haltung eher hochnäsig und unpraktisch. Doch haben wir die Ausführung solcher Handlungen im Sinn, wenn wir sagen „der Chef hat eine neue Suppe kreiert"?

Offensichtlich unterscheidet sich die Bedeutung von „Kreation" im Hinblick auf die Rolle des Chefs beim Kochen einer Suppe von der rein manuellen Küchenarbeit. Dies entspricht fast Joseph Margolis' Bemerkung, Picasso habe mit *Les Demoiselles d'Avignon* eine neue Art der Malerei geschaffen, und seiner Feststellung, dass „er dies anscheinend *durch Verwendung von Ölfarben* nicht hätte tun können"[5]. Wenn daher die Guixé-Schürze als eine Chefschürze angesehen werden kann, so nicht allein als willkürlich ausgewähltes Statussymbol (wie beispielsweise die Königskrone), sondern weil sie auch ein Objekt darstellt, das die ontologische Eigenheit verkörpert, welche die Arbeit seines Nutzers hervorruft. Relevante Rezepte, Kunstwerke oder Designprojekte sind Margolis zufolge „kulturell aufkommende Gebilde, Zeichen-eines-Typs, die in physischen Objekten enthalten sind"[6].

être considéré comme un tablier de chef, ce n'est pas au seul titre symbolique arbitrairement choisi de statut social (comme la couronne du roi, par exemple) mais parce que le tablier est un objet qui incarne en outre la spécificité ontologique du travail produit par son utilisateur. Des recettes pertinentes, des œuvres d'art ou des projets de design sont, selon Margolis, «des entités culturellement émergentes, des symboles vivants, incarnés dans des objets concrets»[6]. Leurs créateurs, simultanément, amalgament des ingrédients concrets, manipulent des concepts en vue de créer un nouvelle formule de soupe, de peinture ou de tablier. La souplesse du tablier, qu'un seul geste soulève, définit la frontière entre «faire» et «créer» et la différence d'attitude entre celui qui «crée» et celui qui «fait». Ceci implique que la fonction première du tablier de Guixé doit, selon les termes de Schiffer, être considérée comme une *ideofunction*, symbole d'idées, de valeurs abstraites ou de convictions. Si le chef cuisinier s'abandonne aux actions matérielles de hacher et découper, le tablier va inéluctablement glisser, ce qui ne manquera pas de lui rappeler qu'il faut garder une certaine distance à l'égard du monde physique et travailler avec son esprit.

concepts in order to create a new type of soup, painting or apron. The light laxity of the apron, aroused by a single gesture, defines the boundary between "making" and "creating" and the different attitudes related to "creators" and "makers". Following this, the proper function of the Guixé apron has to be considered, in Schiffer's terms, as an ideofunction which symbolises abstract ideas, values or beliefs. If the chef gets carried away by the chopping and slicing, then the apron slips down, reminding you to keep a distance from the physical world and work with your mind. It is easy to come back from a trip to Guixéland with the certainty of having visited the realm of the ideofunction. Most of the projects have an unambiguous pedagogical goal: *Autoband*, a tape printed with a pattern of a three-lane highway, is a home toy that allows children to "learn abstract concepts such as politics, lobbying, public relations, public opinion, ecology, territoriality."[7] *HiBye* are pills for the survival of nomadic workers in generic spaces, each "basic unit" putting a statement in a nutshell, such as "carry nothing", "approach everyone" or "consider everywhere as indoor"; *Beach Towel Politics* translates the great political traditions into everyday micropolitical attitudes.

Ihre Schöpfer rühren physische Zutaten und schaffen ein besonderes Zeichen einer Suppe, eines Gemäldes oder einer Schürze. Dabei manipulieren sie gleichzeitig Begriffe, um einen neuen Typ von Suppe, Gemälde oder Schürze entstehen zu lassen. Die leichte, von einer einzigen Geste bewirkte Schlaffheit definiert die Grenze zwischen „machen" und „kreieren" sowie die unterschiedlichen mit „Schöpfern" und „Machern" verbundenen Haltungen. Demzufolge muss die eigentliche Funktion der Guixé-Schürze mit Schiffers Worten als Ideofunktion betrachtet werden, die abstrakte Ideen, Werte oder Anschauungen symbolisiert. Wenn der Chef durch das Hacken und in Scheiben Schneiden in Fahrt gerät, rutscht die Schürze hinunter und erinnert ihn daran, dass man von der physischen Welt Abstand halten und mit dem Kopf arbeiten sollte.

Mit der Gewissheit, das Reich der Ideofunktion besucht zu haben, fällt es leicht, von einem Ausflug ins Guixéland zurückzukehren. Die meisten Projekte haben ein eindeutig pädagogisches Ziel: *Autoband*, ein mit dem Muster einer dreispurigen Autobahn bedrucktes Band, ist ein Spiel, mit dem Kinder zuhause „abstrakte Begriffe erlernen können wie Politik, Lobbying, Öffentlichkeitsarbeit, öffentliche Meinung, Ökologie und Territorialität."[7] *HiBye*

De retour du Guixéland, on se convainc facilement d'avoir visité le monde de l'idéofonction. La plupart des projets ont sans ambiguïté un objectif pédagogique: *Autoband* est un ruban adhésif imprimé d'un motif d'autoroute à trois voies. C'est un jeu pour l'intérieur qui permet aux enfants «de se familiariser avec des concepts abstraits comme la politique, les groupes de pression politiques, les relations publiques, l'opinion publique, l'écologie, la territorialité»[7]; les pillules *HiBye* qui assurent la survie des travailleurs itinérants à l'intérieur d'espaces génériques; chaque «unité de base» renferme dans une coquille de noix un conseil comme «n'emportez rien avec vous», «parlez à tout le monde sans discrimination», «considérez que vous êtes partout à l'intérieur». *Beach Towel Politics* (la politique du drap de bain) permet d'interpréter les grandes traditions politiques en comportements micropolitiques tels qu'ils se présentent dans la vie quotidienne. Ce sont là des objets qui font réfléchir, des objets enchantés plus efficaces que le langage pour véhiculer des concepts et des propos complexes. Il convient de garder à l'esprit qu'en Guixéland, ce sont des livres qui permettent de régler la hauteur des sièges (ce qui est le cas de la chaise *Galeria H$_2$O*, une chaise dont

Things to think, enchanted objects that prove to be more efficient than language in transmitting complex ideas and intentions. Do not forget that in Guixéland people even use books to sit on with the *Galeria H$_2$O Chair*, a chair "where you regulate the height adding books."[8]

The expansive intellectual ambitions that grow in Guixéland express themselves through a humble material environment. Visitors receive a meagre meal of small objects, low technology and unimposing forms. Nothing is outside the control of a system that assures modesty and sobriety, to the point that the exuberance of nature is supplanted by indoor surrogates such as the *Plant Emulator* green tape, or the *Gin Tonic Puddle* and the *Cacao Dune*, pseudo-natural objects for office and home. Perhaps an exception of this vow of poverty imposed on Guixélanders can be found in *Kitchen City*, a sort of hunters and gatherers resort where survival becomes a form of quality leisure and sport. A place where fish are always biting, fruit trees are bountiful and there is no danger, except maybe of falling into the water while trying to take the perfect photo. *Kitchen City* is better understood

Pillen für das Überleben von Nomadenarbeitern in allgemeinen Räumen; jede „Basiseinheit" formuliert eine bündige Erklärung wie „trage nichts", „nähere dich jedem" oder „betrachte überall als innen"; *Beach Towel Politics* übersetzt die großen politischen Traditionen in alltägliche mikropolitische Einstellungen. Nachdenkliches, hinreißende Objekte, die sich beim Übermitteln von komplexen Ideen und Absichten effizienter als die Sprache erweisen. Vergessen Sie nicht, dass in Guixéland die Menschen sogar Bücher zum Sitzen verwenden mit dem *Galeria H$_2$O Chair*, einem Stuhl, „bei dem die Höhe durch Hinzufügen von Büchern eingestellt wird."[8]

Die ausgedehnten, im Guixéland wachsenden intellektuellen Ambitionen drücken sich durch ein bescheidenes materielles Umfeld aus. Besucher erhalten eine kärgliche Mahlzeit aus kleinen Objekten, ohne Hightech und mit unscheinbaren Formen. Nichts entzieht sich der Kontrolle eines Systems, das Einfachheit und Nüchternheit garantiert bis zu dem Punkt, an dem der Reichtum der Natur von Zimmer-Surrogaten verdrängt wird wie etwa dem grünen Band *Plant Emulator* oder dem *Gin Tonic Puddle* und der *Cacao Dune*, pseudonatürlichen Objekten für Büro und Heim. Eine Ausnahme von diesem Guixéländern aufgedrängten Gelübde der Armut findet sich wohl

on règle la hauteur grâce à des piles de livres).[8] Les vastes ambitions intellectuelles qu'on trouve à Guixéland sont exprimées dans des matériaux que caractérisent la pauvreté et l'humilité. Les visiteurs reçoivent pour pitance une portion congrue de petits objets *low-tech* dont la forme extérieure ne paie pas de mine. Rien n'échappe au contrôle d'un système qui garantit modestie et sobriété, à tel point, même, qu'à l'exubérance de la nature se substituent des suppléants pour l'intérieur comme le ruban adhésif vert *Plant Emulator* (Simulateur de plantes), le *Gin Tonic Puddle* (mare de Gin Tonic) et la *Cacao Dune* (dune de cacao), objets qui simulent la nature, pour le bureau et la maison. Une exception à ce vœu de pauvreté imposé aux habitants de Guixéland est peut-être la *Kitchen City*, sorte de lieu de séjour des adeptes de la chasse et de la cueillette où le problème de la survie relève du sport et d'une forme de loisir de qualité. Ici les poissons n'ont de cesse de mordre à l'hameçon, les arbres fruitiers offrent leurs fruits en abondance et le seul danger connu est le risque de tomber à l'eau en cherchant à faire la photo idéale. On comprend mieux *Kitchen City* à la lumière de son prédécesseur: *Sponsored Food*, système en vertu duquel

related to one of its precedents: *Sponsored Food*, a system in which bands of nomadic artists are provided with food by corporations instead of by nature. Guixélanders are sort of primitive predators obtaining energy from the cracks in the world system in late modernity. Martí Guixé is the designer of the tools that allow them to detect, grasp and share the contents of each new crack. Guixélanders, as clever parasites, go for understatement rather than overstatement, and thus need discreet tools to be used with tact and care. As happens with the *Non Visible Ring*, the existence of such a place as Guixéland is only possible under the protection of mimicry and a bit of parody. Apparently the world remains unaffected, but then, as an emancipatory sign, your apron comes lightly loose.

_Octavi Rofes, April 2003

1. Ed van Hinte (ed). *1:1 Martí Guixé* (Rotterdam: 010 Publishers, 2001). 2. Alfred Gell, *Art and Agency: An Anthropological Theory* (Oxford: Clarendon Press, 1998), p. 232. 3. A second consequence of the coherence of Guixé work is that it produces a sort of fractal effect where each single object has the appearance and the qualities of the whole. 4. Michael B. Schiffer, *Technological Perspectives on Behavioral Change* (Tucson and London: The University of Arizona Press, 1992). 5. Joseph Margolis, "The Ontological Peculiarity of Works of Art", John W. Bender and H. Gene Blocker (eds), *Contemporary Philosophy of Art: Readings in Analytic Aesthetics* (New Jersey: Prentice Hall, 1993), p. 318. 6. Joseph Margolis, "The Ontological Peculiarity of Works of Art", p. 321. 7. Ed van Hinte (ed). *Martí Guixé 1:1*, p. 46. 8. Ed van Hinte (ed). *Martí Guixé 1:1*, p. 17.

in *Kitchen City*, einer Art Zufluchtstätte für Jäger und Sammler, in der das Überleben zu einer Form von erstklassiger Freizeit- und Sportaktivität wird. Ein Ort, an dem Fische immer anbeißen, Obstbäume in Hülle und Fülle vorhanden sind und keine Gefahren bestehen, außer vielleicht ins Wasser zu fallen beim Versuch, das perfekte Foto zu machen. *Kitchen City* ist besser verständlich im Zusammenhang mit einem seiner vorausgegangenen Objekte: *Sponsored Food*, ein System, in dem Scharen von Nomadenkünstlern durch Handels-Gesellschaften anstatt durch die Natur mit Nahrung versorgt werden. Guixéländer sind eine Art primitive Plünderer, die ihre Energie aus den Rissen im Weltsystem der späten Moderne erhalten. Martí Guixé ist der Designer der Instrumente, die es ihnen ermöglichen, jeden neuen Riss aufzudecken, sich anzueignen und den Inhalt zu genießen. Als clevere Parasiten streben Guixéländer eher nach Understatement als nach Overstatement und benötigen daher dezente, mit Feingefühl und Sorgfalt zu gebrauchende Instrumente. Wie beim *Non Visible Ring* ist die Existenz eines solchen Ortes wie Guixéland nur möglich unter dem Schutz von Nachahmung und ein wenig Parodie. Anscheinend bleibt die Welt unberührt, doch dann, emanzipatorisches Zeichen, lockert sich leicht die Schürze. _Octavi Rofes, April 2003

l'alimentation était fournie à des bandes d'artistes nomades par des sociétés de sponsors et non par la nature. Les habitants de Guixéland sont en quelque sorte des prédateurs primitifs; ils puisent leur énergie dans les fissures du système qui régit le monde en cette modernité tardive. Marti Guixé est le créateur d'instruments qui leur permettent de détecter, de s'approprier et de partager le contenu de chaque nouvelle fissure. Les Guixélanders sont des parasites intelligents. Ils visent l'atténuation et non l'hyperbole. Aussi ont-ils besoin d'instruments discrets que l'on utilise avec prudence et soin. A la manière dont se manifeste le *Non visible Ring*, l'existence d'un lieu tel que Guixéland suppose nécessairement la protection d'un mimétisme quelque peu parodique. En apparence, le monde reste inchangé, mais, signe d'émancipation, le tablier s'est un peu détendu. _**Octavi Rofes, Avril 2003**

1. Ed van Hinte (ed). *1:1 Martí Guixé* (Rotterdam: 010 Publishers, 2001). 2. Alfred Gell, *Art and Agency: An Anthropological Theory* (Oxford: Clarendon Press, 1998), p. 232. 3. Cette cohérence interne de l'œuvre de Guixé a une deuxième conséquence : elle produit une sorte d'effet fractal là où chaque élément singulier a l'aspect et les qualités de l'ensemble. 4. Michael B. Schiffer, *Technological Perspectives on Behavioral Change* (Tucson and London: The University of Arizona Press, 1992). 5. Joseph Margolis, «The Ontological Peculiarity of Works of Art», John W. Bender and H. Gene Blocker, (eds) *Contemporary Philosophy of Art:* Readings in Analytic Aesthetics (New Jersey: Prentice Hall, 1993), p. 318. 6. Joseph Margolis, «The Ontological Peculiarity of Works of Art», p. 321. 7. Ed van Hinte (ed). *Martí Guixé 1:1*, p. 46. 8. Ed van Hinte (ed). *Martí Guixé 1:1*, p. 17.

1. Ed van Hinte (ed). *1:1 Martí Guixé* (Rotterdam: 010 Publishers, 2001). 2. Alfred Gell, *Art and Agency: An Anthropological Theory* (Oxford: Clarendon Press, 1998), p. 232. 3. Eine zweite Folge der Kohärenz in Guixés Arbeiten besteht darin, dass sie einen gewissen fraktalen Effekt aufweisen, wonach jedes einzelne Ding die Form und die Qualität des Ganzen aufweist. 4. Michael B. Schiffer, *Technological Perspectives on Behavioral Change* (Tucson and London: The University of Arizona Press, 1992). 5. Joseph Margolis, "The Ontological Peculiarity of Works of Art", John W. Bender and H. Gene Blocker (Hg.), *Contemporary Philosophy of Art: Readings in Analytic Aesthetics* (New Jersey: Prentice Hall, 1993), p. 318. 6. Joseph Margolis, "The Ontological Peculiarity of Works of Art", p. 321. 7. Ed van Hinte (Hg.).*1:1 Martí Guixé*, p. 46. 8. Ed van Hinte (Hg.). *1:1 Martí Guixé*, p. 17.

6 t-shirts qui reproduisent et attirent l'attention sur le tissu social de Barcelone. Touriste permanent, DJ, artiste engagé politiquement, ex-designer, consommateur et chef, de Barcelone, 2003. _Permanent tourist / DJ / Social artist / Ex-designer / Consumer / Chef / Produits par **CHA-CHÁ, 2003**

6 t-shirts that reproduce and point to the local social fabric. Permanent tourists, DJs, social artists, ex-designers, consumers and chefs, in Barcelona, 2003. _Permanent Tourist / DJ / Social Artist / Ex-designer / Consumer / Chef / Produced by **CHA-CHÁ, 2003**

Sechs T-Shirts, welche die lokale Gesellschaftsstruktur wiedergeben und auf sie hinweisen. Ständige Touristen, DJs, sozial engagierte Künstler, Ex-Designer, Verbraucher und Chefs, in Barcelona, 2003. _Permanent Tourist / DJ / Social artist / Ex-designer / Consumer / Chef / Hergestellt von **CHA-CHÁ, 2003**

WE RECOMEND YOU
PLACE FLAMP
BESIDE A CONVENTIONAL
LAMP

LIGHT IS ON

TURN OFF!
YOU HAVE 20 MIN.
TIME BEFORE YOU
ARE IN DARK.
ENJOY THE SHADOW!

Ceci n'est pas une lampe mais un objet lumineux qui a la forme d'une lampe. L'objet, revêtu de peinture phosphorescente, émet une lumière dans l'obscurité pendant près de vingt minutes dès que les autres éclairages artificiels sont éteints. _Flamp / Produit par la Galeria H_2O / Barcelone, 1998.
La chaise «Galeria H_2O» s'adapte à vos besoins par l'adjonction de livres. Les livres d'architecture sont particulièrement conseillés car ils sont généralement plus gros que les autres. _Galeria H_2O chair / Produit par la Galeria H_2O, Barcelone, 2000

This is not a lamp but a luminous object in the shape of one. Painted with phosphorescent paint, it emits light in the darkness for some 20 minutes after the other lights have been turned off. _Flamp / Produced by Galeria H_2O / Barcelona, 1998.
The "Galeria H_2O chair" can be customised by means of books, with architecture books working the best as they tend to be bigger. _Galeria H_2O chair / Produced by Galeria H_2O / Barcelona, 2000

Dies ist keine Lampe, sondern ein Leuchtobjekt in Gestalt einer solchen. Mit phosphoreszierender Farbe bemalt, strahlt sie in der Dunkelheit etwa 20 Minuten Licht aus, nachdem die anderen Beleuchtungen ausgeschaltet worden sind. _Flamp / Hergestellt von Galeria H_2O / Barcelona 1998.
Die Höhe des „Galeria H_2O Chair" lässt sich mit Hilfe von Büchern anpassen, am besten mit Architekturbüchern, weil sie gewöhnlich dicker sind. _Galeria H_2O chair / Hergestellt von Galeria H_2O / Barcelona, 2000

A CHAIR FOR YOUR WHOLE LIFE

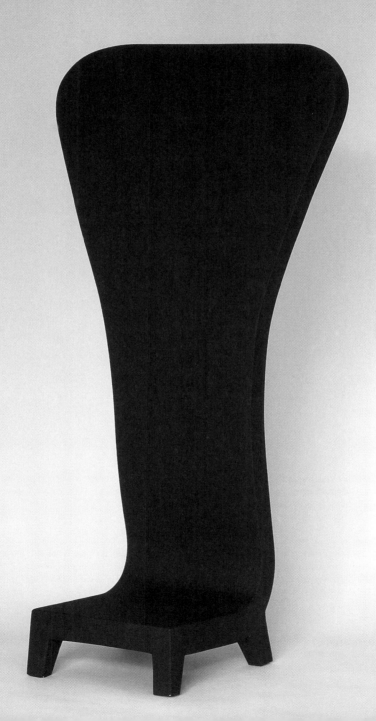

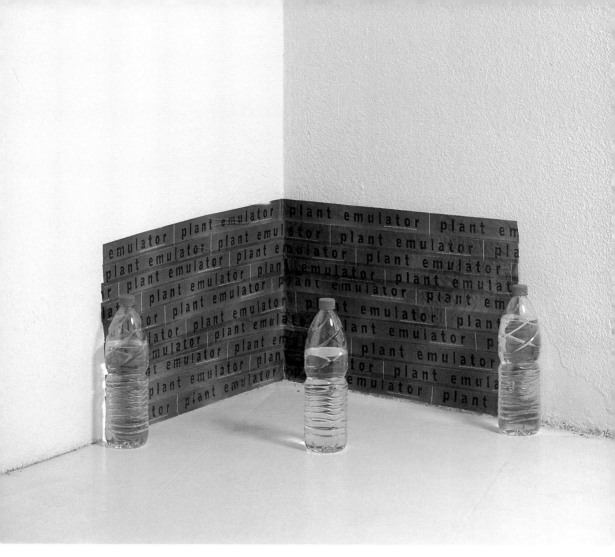

Dans les bureaux et les intérieurs, l'usage de plantes est généralement purement décoratif; la plante a pour unique fonction d'introduire une tache verte. Le simulateur de plantes imite cette fonction: il crée la tache verte et vous épargne la plante. Il préserve la fonction et vous débarrasse de l'objet. _**Plant Emulator Tape / 77 multiples signés et numérotés, 2002**

Normally in office and domestic interiors the use of plants is purely decorative, with the plant's function reduced to the task of providing a blotch of green colouring. Plant emulator emulates this function by creating a green blotch without needing the plant, thus preserving the function while doing away with the object. _**Plant Emulator Tape / 77 signed and numbered multiples, 2002**

Normalerweise sind Pflanzen in Büro- und Wohnungseinrichtungen rein dekorativ, wobei sich die Funktion der Pflanze auf die Aufgabe reduziert, für einen Flecken Grün zu sorgen. Plant emulator strebt diese Funktion an, indem das Band einen grünen Klecks schafft, ohne eine Pflanze zu benötigen. So wird die Funktion beibehalten und das Objekt beseitigt. _**Plant Emulator Tape / 77 signierte und nummerierte Multiples, 2002**

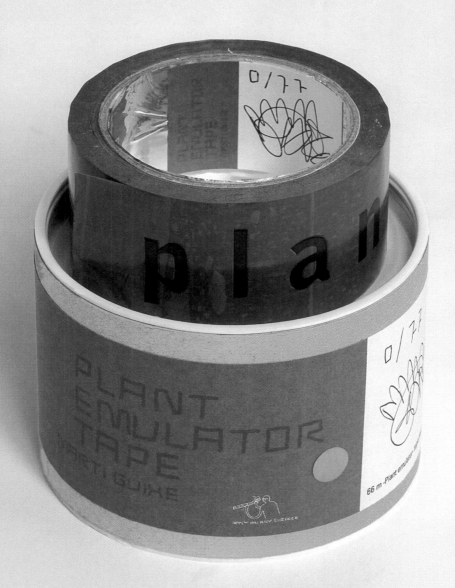

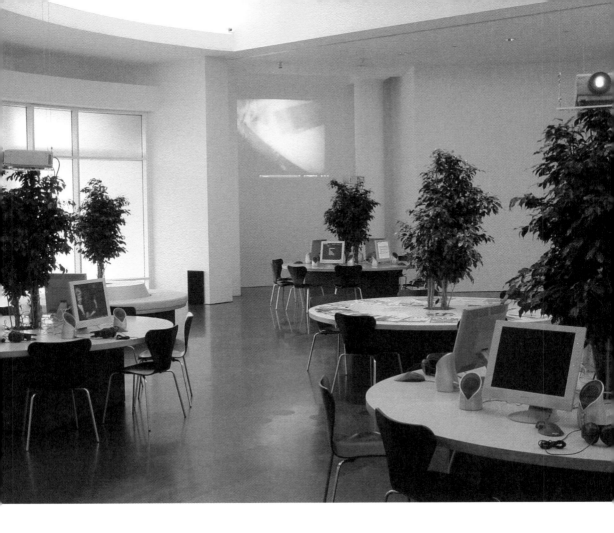

Même en suivant plusieurs fois de suite les mêmes instructions, on obtient chaque fois un résultat différent. L'arbre multi fonctionnel est un système sans forme puisque sa forme est dans chaque cas adaptée au nouveau contexte. Le résultat dépend de structures micro politiques qui se manifestent chaque fois différemment, et ont toujours un corps différent. _Mptree for Sonic Process / MACBA, Barcelone, 2002 _Mptree for Sonic Process / Centre Pompidou, Paris, 2002

Even when following the same instructions, a different result can come about. Multi-purpose tree is a system without shape, since its shape is adapted to the context; it is the result of micro-political structures which come out differently every time, always with a different body. _Mptree for Sonic Process / MACBA, Barcelona, 2002 / Mptree for Sonic Process / Centre Pompidou, Paris, 2002

Selbst wenn dieselbe Anweisung befolgt wird, kann es zu einem unterschiedlichen Ergebnis kommen: Der Vielzweck-Baum ist ein System ohne Gestalt, da seine Form dem Kontext angepasst ist; er resultiert aus mikropolitischen Strukturen, die sich jedes Mal anders zeigen, stets mit einem anderen Körper. _Mptree für Sonic Process / MACBA, Barcelona, 2002 / Mptree für Sonic Process / Centre Pompidou, Paris, 2002

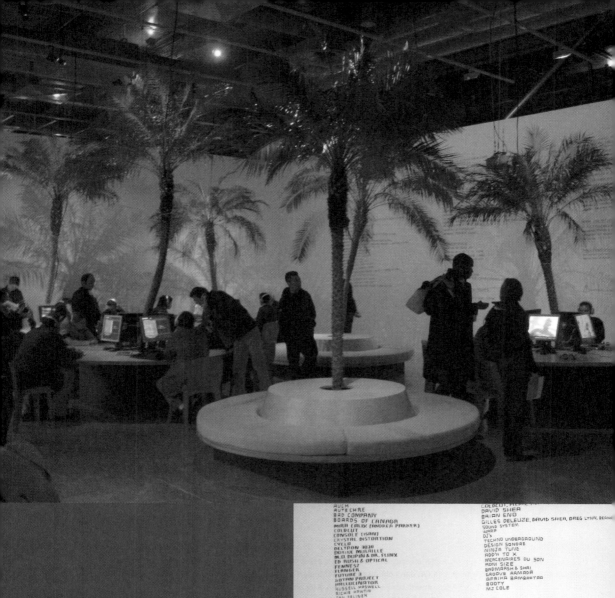

AUCH
AUTECHRE
BAD COMPANY
BOARDS OF CANADA
MIRA CALIX (ANDREA PARKER)
COLDCUT
CONSOLE (ISAN)
CRYSTAL DISTORTION
CYCLO
DELTRON 3030
DORIAN MURAILLE
M.O. DUPIN & DR. FLINX
ED RUSH & OPTICAL
FENNESZ
FLANGER
FUTURE 3
GOTAN PROJECT
HALLUCINATOR
RUSSELL HASWELL
RICHIE HAWTIN
IAN JELISEN
KID KOALA
KIT CLAYTON
LALI PUNA
LUOMO
MASKING
MONOLAKE
MR. SCRUFF / GLEN BROWN/ KING TUBY
MUM
MUSLIMGAUZE
NEOTROPIC
OVAL
PAN SONIC
PITA
PHROZ
POLE
PREFUSE 73
BOGDAN RACZYNSKI
RANDOM INC.
AERRYMADE & DAVID SYLVIAN
MECHENZENTRUM
RHYTHM & SOUND (featuring CORNEL CAMPBELL)
ROB & BERNARD PARMEGGIANI
ROOTS MANUVA
SCANNER & FUNK
S.I. FUTURES
DAVID SHER
SNUKLY
SOLAR
SPEEDY J
SQUAREPUSHER
STEREOTYP & TIKIMAN
STEREOFORM
TENNIS
AMON TOBIN
TO ROCOCO ROT
TOSCA
TWINE
TWO LONE SWORDSMEN
ULTRA MILKMAIDS & BLUE BABOON
UNIT
W. PRICE
WAGON CHRIST
SUSUMU YOKOTA

COLDCUT, HEXSTATIC
DAVID SHER
BRIAN ENO
GILLES DELEUZE, DAVID SHER, GREG LYNN, BERNAR
SOUND SYSTEM
WARP
DJ's
TECHNO UNDERGROUND
DESIGN SONORE
NINJA TUNE
ADD'N TO X
MERCENAIRES DU SON
RONI SIZE
BADMARSH & SHRI
GROOVE ARMADA
AFRIKA BAMBAATAA
BOOTY
MJ COLE

75

1

2

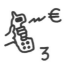
3

4

5

6

Le banc alimentaire est un système de restaurant sans salle à manger. Avant les Jeux Olympiques de Barcelone de 1992, dans le Barrio de la Barceloneta, près de la plage il y avait un restaurant appelé El Gato Negro qui, s'il disposait d'une cuisine, n'avait pas de salle à manger. Les chaises et les tables étaient installées sur le sable de la plage mais, dès qu'il se mettait à pleuvoir, le restaurant ne pouvait plus servir. Food Bank est un système graphique qui, à la manière des graffiti, parasite les bancs publics. Ce système graphique consiste en un menu, un numéro d'identification inscrit sur le banc et un numéro de téléphone. Si l'on désire utiliser ce service, il suffit de téléphoner, on passe sa commande,

Food Bank is a system of restaurants without dining rooms. Before the 1992 Olympic Games in Barcelona, in the Barrio de la Barceloneta near the beach, there was a restaurant called El Gato Negro that did not have a dining room, just a kitchen. The chairs and tables were on the sand on the beach, so that if it rained they couldn't serve meals. Food Bank is a graphic system, which like graffiti parasites a common city bench. This graphic system consists of a menu, an identification number on the bench and a telephone number. Those wishing to use the service call the number, ask for the menu options, pay through their cell phones and indicate the city bench ID number that locates them

Food Bank ist ein System von Restaurants ohne Speiseräume. Bevor 1992 die Olympischen Spiele in Barcelona stattfanden, gab es im Barrio de la Barceloneta, in der Nähe des Strandes das Restaurant El Gato Negro, das keinen Speiseraum hatte, sondern nur eine Küche. Die Stühle und Tische standen im Sand am Strand, so dass bei Regen keine Mahlzeiten serviert werden konnten.
Food Bank ist ein grafisches System, das wie Graffiti auf einer gewöhnlichen Stadtbank schmarotzt. Dieses grafische System besteht aus einer Speisekarte, einer Kennzahl auf der Bank und einer Telefonnummer. Wer den Service in Anspruch nehmen möchte, ruft die Nummer an, erkundigt sich nach der Menüauswahl, bezahlt über ihr Mobilfunktelefon und gibt die Kennzahl der Stadtbank an, damit man ihn

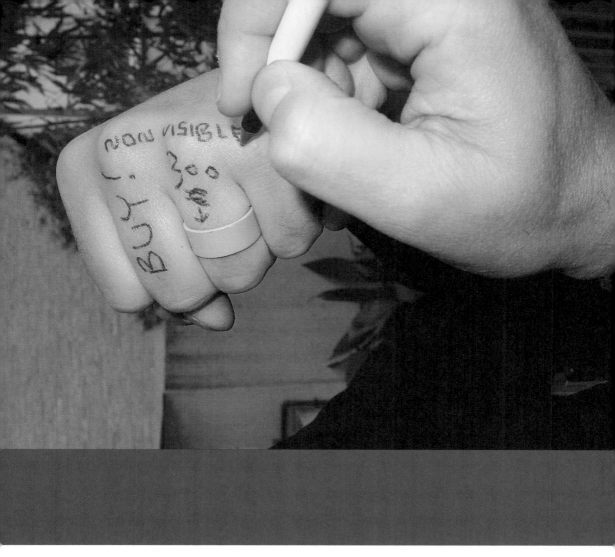

on paye par téléphone et on précise le numéro d'identification du banc qui indique l'emplacement du client. Le repas peut ainsi être livré en quelques minutes. _Food Bank / conception et réalisation, 2001

La «bague invisible» est un anneau d'argent peint dans un ton de chair. C'est un anneau qui permet de sceller, non pas les contrats écrits, mais les contrats verbaux. _Non-visible Ring / Produit par la Galeria H₂O, 10 exemplaires signés et numérotés, 2003

so that the food can be delivered within a few minutes. _Food Bank / concept and piece, 2001

"Non visible ring" is a silver ring painted in a skin tone. It is a ring to seal verbal, not written contracts. _Non-visible Ring / Produced by Galeria H₂O in an edition of 10 signed and numbered units, 2003

lokalisieren kann. Das Essen wird innerhalb weniger Minuten geliefert. _Food Bank / Konzept und Werk, 2001

„Nicht sichtbarer Ring" ist ein silberner, in einem Hautfarbton bemalter Ring. Der Ring soll mündliche, nicht schriftliche Verträge besiegeln. _Non-visible Ring / Hergestellt von Galeria H₂O in einer Auflage von zehn signierten und nummerierten Stück, 2003

EL PINTXO DE LA CUMBRE de DONOSTIA / SAN SEBASTIAN

Arteleku (Diputación Foral de Gipuzkoa) en colaboración con consonni celebra del 5 al 9 de mayo, *Transazkio denbora. The Timing of Transaction*. la cumbre de Donostia / San Sebastián y reúne artistas, pensadores, diseñadores, arquitectos, directores de instituciones procedentes de Euskadi y Catalunya, Alemania, Austria, Corea, Francia, Grecia, Holanda, India, Italia, Noruega, Reino Unido, Senegal y Suecia.

El pintxo de la cumbre de Donostia / San Sebastián es un proyecto de Martí Guixé para Transazkio denbora. The Timing of Transaction. Del 5 al 10 de mayo de 2003, en varios bares de la ciudad, se ofrece al público un pintxo especial derivado de la mezcla de tres pintxos ya existentes.

ALOÑA BERRI BAR
c/ Bermingham, 24

BAR BERGARA
General Artetxe, 8

ITURRIOZ
Aldamar, 12

IZKIÑA
Fermin Calbetón, 4

IRAETA
Padre Larroca, 2

TABERNA MENDI
San Francisco, 13

LA VIÑA
31 de Agosto, 3

ITURRIOZ
San Martin, 30

**LA CUCHARRA
DE SAN TELMO**
31 de Agosto, 28

arteleku | consonni

Con el apoyo de la AFAA, Instituto francés de Bilbao y Gobierno Vasco - Departamento de Cultura

Un «pintxo» est un snack caractéristique du Pays Basque. Il y a de nombreuses variétés de pintxos et toutes sortes de pintxo bars.
Il s'agissait ici de créer un système qui permettrait à un certain nombre de pintxo bars de faire chacun un pintxo spécial pendant la semaine qu'a duré un congrès de critiques d'arts et de curateurs dans la ville de San Sebastián. Dans le système proposé initialement, le barman était le curateur car c'est à lui que revenait la tâche de choisir ses trois meilleurs pintxos — trois meilleurs ou tout simplement ses trois pintxos préférés, ou bien encore ses trois pintxos les plus demandés, ou encore les trois pintxos qui l'intéressent le plus pour des raisons économiques.

A "pintxo" is a typical snack from the Basque Country. There are many kinds of pintxos and all kinds of pintxo bars.
The idea was to create a system whereby different pintxo bars could make a special one during the week of a summit meeting of art critics and curators in the city of San Sebastián. The system initially proposed that the barman would be the curator, as he would have to decide on his three best pintxos – they could just as well be his three favourites– or his three best-selling pintxos, or just as well the three that interested him for economic reasons, all to be decided in line with his own criteria. These three pintxos would then be put into a blender and

Ein „pintxo" ist ein typischer Snack aus dem Baskenland. Es gibt viele Arten von pintxos und die verschiedensten Pintxo-Bars.
Es sollte ein System geschaffen werden, mit welchem in der Woche eines Gipfeltreffens von Kunstkritikern und Kuratoren in San Sebastián verschiedene Pintxo-Bars ihren Spezial-Pintxo kreieren konnten. Das System sah zunächst vor, dass der Barbesitzer der Kurator sein würde, da er sich für seine drei besten Pintxos entscheiden müsse; dies konnten ebensogut seine drei Lieblings-Pinxtos sein – oder seine drei meistverkauften oder die drei, die für ihn aus wirtschaftlichen Gründen am interessantesten waren; alle sollten in Einklang mit seinen eigenen Kriterien bestimmt werden. Diese drei Pintxos würden anschließend gemixt werden. Dies als eine Art Test, um ihre gegenwärtige Qualität zu

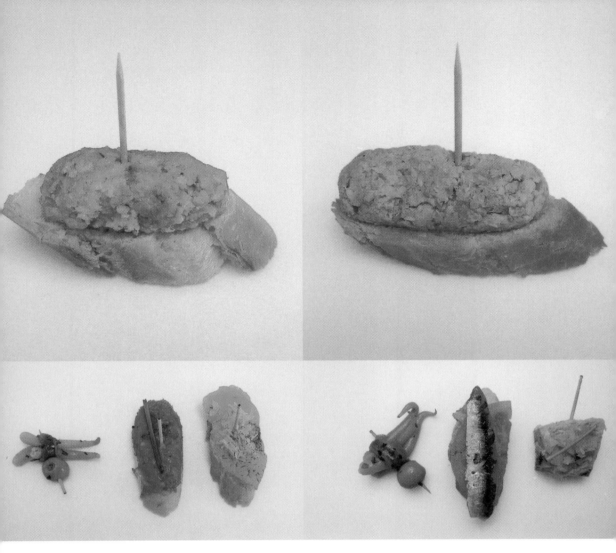

C'est des critères définis par le barman/curateur que dépend le choix de ces snacks. Ces trois pintxos sont ensuite mélangés dans un mixer. Ceci, qui est la transgression d'un tabou, est un test qui permet de définir la modernité, la qualité contemporaine des pintxos. Finalement, le mélange obtenu est le «nouveau» pintxo ou le pintxo des congrès. _The Summit Pintxo, projet / Transakzio Denbora: The Timing of Transaction / Donostia Summit / San Sebastián, 2003

mixed, as a sort of test to define their contemporary quality, since doing this involves breaking a taboo. Finally, with the resultant mix, the new pintxo would be made, "the summit pintxo". _The Summit Pintxo, project / Transakzio Denbora: The Timing of Transaction / Donostia Summit / San Sebastián, 2003

bestimmen, da ein solches Vorgehen einen Tabubruch bedeutet. Mit der Mischung würde der neue Pintxo, „der Gipfel-Pintxo", hergestellt. _The Summit Pintxo, Projekt / Transakzio Denbora: The Timing of Transaction / Donostia Summit / San Sebastián, 2003

PARK I

THE KITCHE

Faire la cuisine n'est plus une nécessité car cette activité est désormais un sport ou, mieux, une activité de loisirs. Mais même ainsi, la préparation des repas se déroule le plus souvent dans un espace fermé associé à la maison, c'est-à-dire dans une cuisine conventionnelle. Les latitudes de ce hobby s'en retrouvent réduites en termes de mobilité et de plaisir. Le design des *Kitchen-Buildings* (bâtiments-cuisines) s'articule autour de la mobilité et de la fonction associées au fait de cuisiner. Leur concept architectural s'efface derrière la chorégraphie de la préparation des mets. La préparation, l'élaboration et la consommation des plats définissent un espace qui est à la fois convivial et fonctionnel.

Cooking is not longer a necessity, having become a sport, or just as well a leisure activity. Even so, it is still done mostly in closed spaces connected to the home, that is, in the space of the conventional kitchen, thus limiting its possibilities in terms of action and pleasure. The Kitchen-Buildings are designed around the action and function of cooking, so that the idea of their architectural structure vanishes as it is expanded into the format of the choreography arising out of the process of preparing foodstuffs. Preparation, elaboration and consumption define a space that is both social and functional.

Kochen ist keine Notwendigkeit mehr – es ist ein Sport oder eine Freizeitbeschäftigung geworden. Trotzdem wird vorwiegend in geschlossenen, an das Zuhause gebundenen Räumen gekocht, das heißt in den Räumlichkeiten der herkömmlichen Küche, wo es kaum Möglichkeiten für Aktivitäten und Vergnügen gibt. Die Kitchen-Buildings sind um die Kochaktion und -funktion herum entworfen. Folglich verschwindet die Vorstellung von ihrem architektonischen Gefüge, sobald es zum choreografischen Format erweitert wird, das aus dem Prozess der Zubereitung von Nahrungsmitteln hervorgeht. Zubereitung, Verfeinerung und Verzehr bestimmen einen Bereich, der sowohl sozial als auch funktional ist.

LIFE

U-BUILDINGS

Dans cette ville de cuisine (*Kitchen-City*), l'espace architectural est chorégraphie et les modules utilitaires deviennent objet d'architecture. Les activités poursuivies dans les Kitchen-Buildings relèvent de la virée dans un parc de loisirs artificiel. Ces éléments peuvent être installés ensemble ou séparément, dans des espaces génériques, à l'intérieur d'espaces publics ou privés et constituer de la sorte une réserve anthropologique en temps réel: la vie de parc (*Park Life*). L'objectif de *Park Life* est de redéfinir la vie quotidienne et de la transformer en sport de loisir et de luxe. _Martí Guixé, Barcelone, Mai 2003

In this kitchen-city the architectural space is the choreography and the kitchen mechanism becomes the architectural object. The Kitchen-Buildings are the active leisure rides of a non-natural amusement park, and can be installed separately or together, in generic, public or private spaces, making up an anthropological park in real time: park life. Park Life seeks to reconsider everyday life as a luxury leisure sport. _Martí Guixé, Barcelona, May 2003

In dieser „Kitchen-City" ist der architektonische Raum die Choreografie und der Küchenablauf wird zum Architekturobjekt. Die Kitchen-Buildings sind die aktiven Freizeitkarusselle eines nicht natürlichen Vergnügungsparks. Sie lassen sich getrennt oder zusammen in allgemeinen, öffentlichen oder privaten Räumen aufstellen und bilden einen anthropologischen Park in Realzeit: park life. Park Life versucht das Alltagsleben als luxuriösen Freizeitsport zu überdenken. _Marti Guixé, Barcelona, Mai 2003

PARK LIFE # 006 / THE OVEN KITCHEN-BUILDING: LE MODULE FOUR
Il s'agit ici d'un four circulaire alimenté au bois. L'espace est clôturé par des murs formés par le bois de chauffage. L'emmagasinage et l'utilisation des bûches se traduit par la métamorphose permanente du plan et de l'apparence de l'édifice qui repose sur un sol légèrement incliné.

PARK LIFE # 006 / THE OVEN KITCHEN-BUILDING
This is a wood-burning circular oven, with the firewood storage making up the walls that close off the space. The storage and use of the logs has the effect of changing the layout of the overall construction. The building is supported and installed on a slight inclination in relation to the horizontal ground.

PARK LIFE #006 / THE OVEN KITCHEN-BUILDING
Hierbei handelt es sich um einen runden Holzbrennofen. Das Brennholzlager bildet die Wände, die den Raum abschließen. Die Lagerung und die Nutzung der Scheite bewirkt ein verändertes Layout der von einem leichten Abhang getragenen Gesamtkonstruktion.

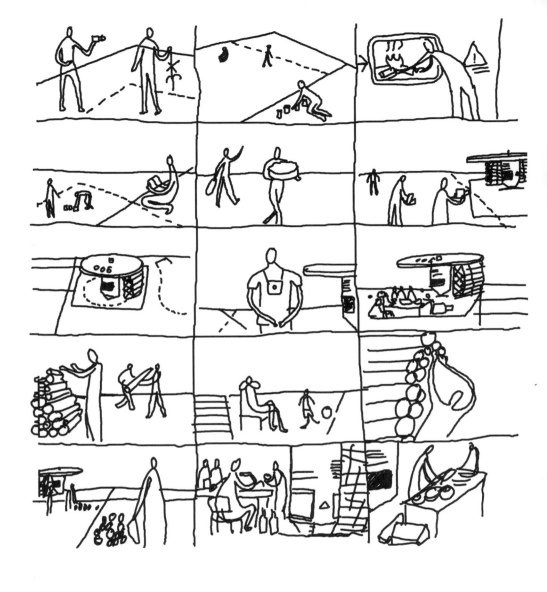

DISCLAIMER

PARK LIFE
SOLAR kitchen/building 1.0

PARK LIFE # 007 / THE SOLAR KITCHEN-BUILDING: MODULE SOLAIRE

Le module solaire peut être déplacé manuellement pour suivre la course du soleil. Il est destiné à des activités d'intérieur, mais peut aussi être utilisé pour prendre ses repas. La cuisson des plats se fait grâce à la concentration des rayons du soleil au point focal de la plateforme intérieure. Une rampe et une ouverture donnent accès au centre du réflecteur.

PARK LIFE # 007 / THE SOLAR KITCHEN-BUILDING

The Solar Kitchen Building can be manually shifted to follow the position of the sun. It allows for activities inside, as well as the possibility of being installed for the consumption of prepared foods. The cooking of the foodstuffs is done through the concentration of the sun's rays in the centre point of the interior platform. A ramp and opening give access to the middle of the reflector.

PARK LIFE #007 / THE SOLAR KITCHEN-BUILDING

Das Solar Kitchen-Building lässt sich von Hand verschieben, um der Sonnenstellung zu folgen. Es gestattet Aktivitäten im Innern und kann auch für den Verzehr von Fertiggerichten aufgestellt werden. Das Kochen der Nahrungsmittel erfolgt durch die Konzentration der Sonnenstrahlen im Mittelpunkt der Innenplattform. Eine Rampe und eine Öffnung gewähren den Zugang zur Mitte des Reflektors.

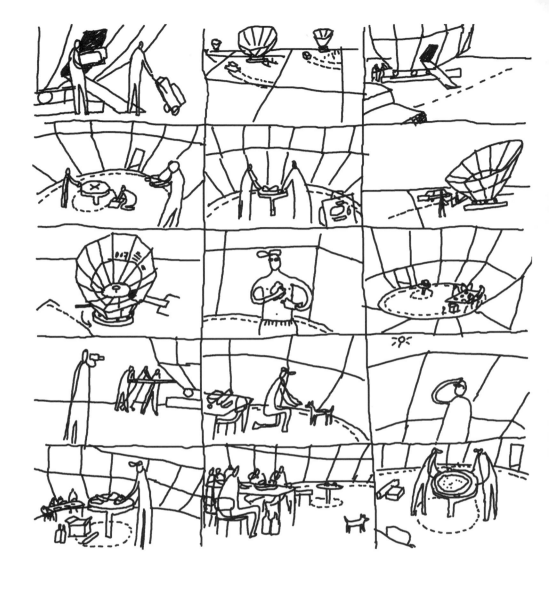

PARK LIFE # 008 / THE FRUIT KITCHEN-BUILDING: LE MODULE VERGER

Une plateforme est fixée au tronc des arbres fruitiers; elle permet la cueillette, la préparation et la consommation de toutes les espèces produites par les arbres fruitiers. Les arbres sont plantés dans d'immenses pots de tailles différentes pour faire en sorte que leurs frondaisons soient au même niveau, juste au-dessus de la plateforme, ce qui n'exige aucun effort pour la cueillette. Comme la plateforme est fixée aux arbres, elle se déplacera en hauteur au fur et à mesure de la croissance du verger. Une rampe donne accès à la plateforme, entièrement entourée d'arbres fruitiers.

PARK LIFE # 008 / THE FRUIT KITCHEN-BUILDING

A platform attached to the trunks of the fruit trees allows for the picking, preparation and consumption of all kinds of fruit in the trees. The trees are planted in large pots of different heights to ensure that they are level just above the platform, so that no special effort is needed in the picking of the fruit. Since it is attached to the trees the platform moves in function of the trees' growth. A ramp gives access to the platform, completely surrounded as it is by the fruit trees.

PARK LIFE #008 / THE FRUIT KITCHEN-BUILDING

Eine an den Baumstämmen von Obstbäumen befestigte Plattform ermöglicht das Pflücken, Zubereiten und Verzehren aller Fruchtsorten in den Bäumen. Die Bäume sind in große, verschieden hohe Töpfe gepflanzt, damit sich ihre Kronen so hoch über der Plattform befinden, dass beim Pflücken der Früchte keine besonderen Anstrengungen unternommen werden müssen. Da die Plattform mit den Bäumen verbunden ist, bewegt sie sich mit dem Wachstum der Bäume. Zu der gänzlich von Obstbäumen umgebenen Plattform führt eine Rampe.

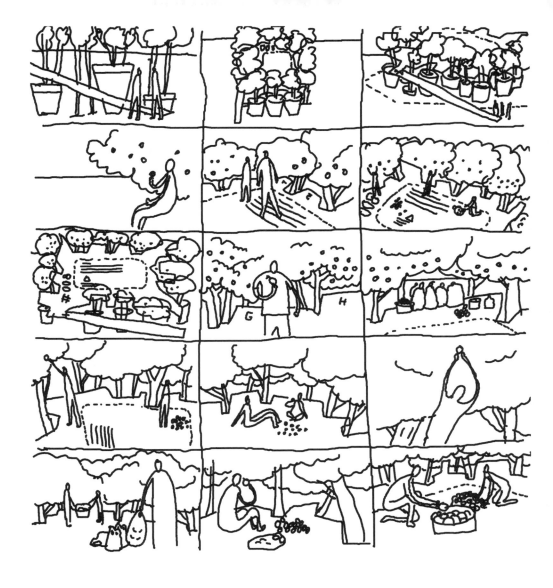

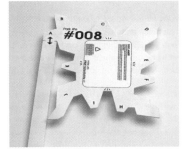

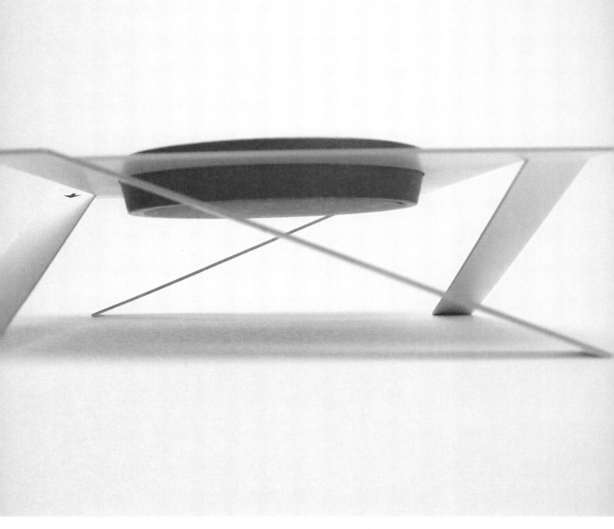

PARK LIFE # 009 / THE SHELLFISH KITCHEN-BUILDING: LE MODULE CRUSTACÉS
Une cuve transparente remplie d'eau salée installée sur une plateforme vous permet de voir le crustacé que vous souhaitez pêcher pour votre dîner. Cette ferme à crustacés permet de disposer simultanément de toutes sortes de crustacés et mollusques de l'océan.
On pourra les extraire de l'extérieur ou directement de l'intérieur de la cuve.

PARK LIFE # 009 / THE SHELLFISH KITCHEN-BUILDING
A transparent saltwater tank on a platform allows for you to see the shellfish you wish to catch for preparation and consumption from below. The shellfish farm facilitates the presence of all kinds of sea crustaceans and molluscs. They can be caught from outside or from within the tank itself.

PARK LIFE #009 / THE SHELLFISH KITCHEN-BUILDING
Ein durchsichtiger Salzwassertank auf einer Plattform ermöglicht es, den Schellfisch von unten zu sehen, den man für die Zubereitung und den Verzehr fischen möchte. Die Schellfischfarm ermöglicht die Verfügbarkeit jeglicher Krusten- und Schalentiere. Sie können von außerhalb des Tanks oder im Tank selbst gefangen werden.

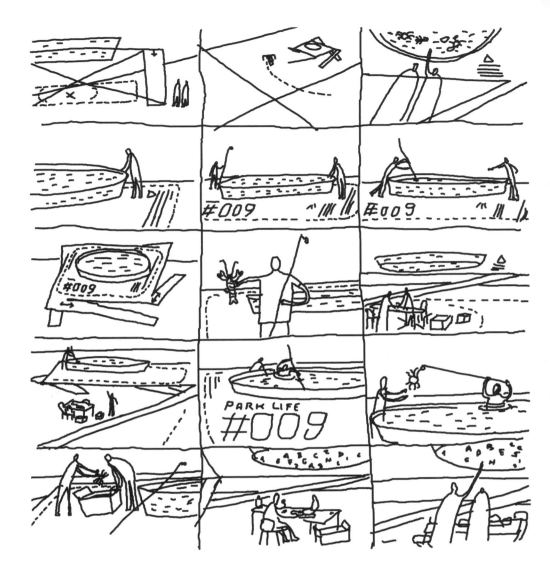

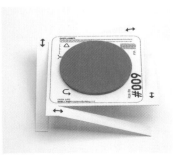

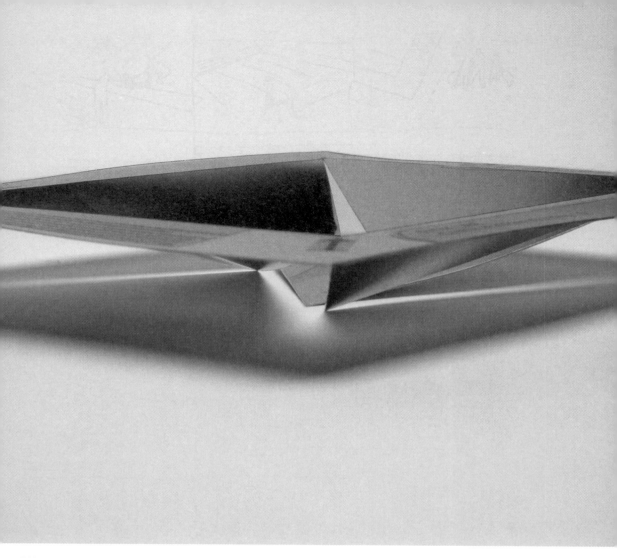

PARK LIFE # 010 / THE GARDEN KITCHEN-BUILDING: LE MODULE JARDIN POTAGER

Un container rempli de terreau est destiné à la culture d'un potager. Sont présents à proximité tous les accessoires nécessaires à l'entretien du potager. On y cueille directement les légumes frais pour la préparation et la consommation. Le container est indépendant de son environnement et peut être installé n'importe où.

PARK LIFE # 010 / THE GARDEN KITCHEN-BUILDING

An earth-filled container for growing plants, with everything needed for the garden's care, allows for fresh vegetables to be picked for preparation and consumption. The container element is independent of its surroundings and can be installed anywhere.

PARK LIFE #010 / THE GARDEN KITCHEN-BUILDING

Ein mit Erde gefüllter Container für den Anbau von Pflanzen und allem Notwendigen für die Gartenpflege, ermöglicht das Pflücken von frischem Gemüse für die Zubereitung und den Verzehr. Das Containerelement lässt sich unabhängig von seiner Umgebung überall aufstellen.

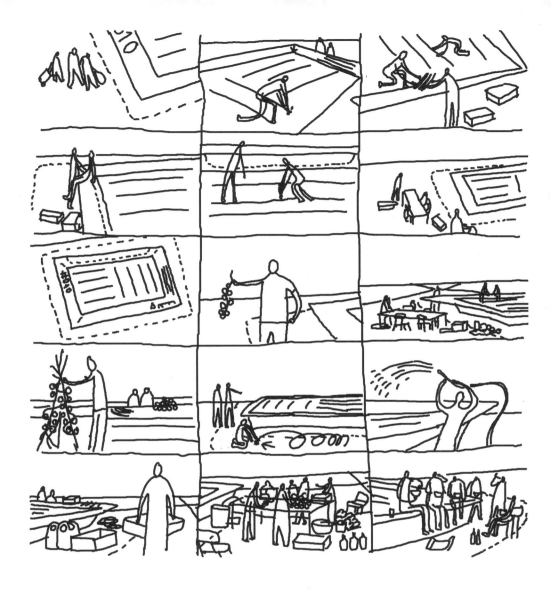

PARK LIFE # 011 / THE SEAFOOD KITCHEN-BUILDING: LE MODULE PISCICULTURE

Cet élément piscicole est installé à proximité de la côte, dans un environnement maritime. Il sera relié à une plateforme qui permettra la capture du poisson, sa préparation et sa consommation immédiates. Une série de marches transparentes permettent de descendre et de voir à l'intérieur de la cuve. Celle-ci n'isole pas les poissons mais permet de faciliter leur capture.

PARK LIFE # 011 / THE SEAFOOD KITCHEN-BUILDING

This is a saltwater fish farm to be located near the coast in a maritime environment, connected to a platform to facilitate the capture, preparation and consumption of fish. A series of transparent steps going down into it means the interior of the tank is visible from without. The tank does not isolate the fish but simply holds them to make them easier to catch.

PARK LIFE # 011 / THE SEAFOOD KITCHEN-BUILDING

Diese Salzwasserfischfarm ist nahe der Küste in einer Meeresregion anzusiedeln. Mit einer Plattform verbunden erleichtert sie den Fang, die Zubereitung und den Verzehr von Fisch. Einige transparente Stufen führen hinein und bieten so einen Einblick in das Tankinnere. Der Tank isoliert nicht die Fische, sondern enthält sie lediglich, um sie leichter fangen zu können.

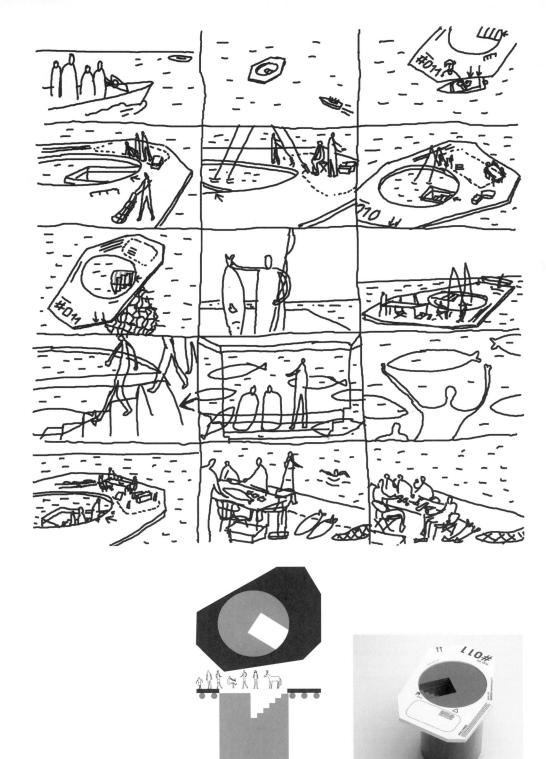

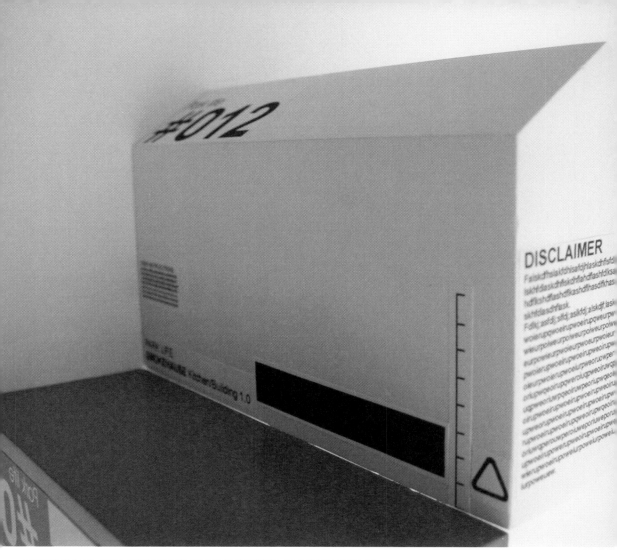

PARK LIFE # 012 / THE SMOKEHOUSE KITCHEN-BUILDING: LE MODULE FUMAGE

Le module comprend un espace pour le fumage et peut également servir de lieu de rangement pour les instruments et l'équipement néces-saires au processus de fumage; il sera installé à côté d'un établissement piscicole alimenté en eau douce. Les poissons destinés au fumage seront capturés in situ; c'est ici également qu'auront lieu préparation et consommation. Le module pourra également servir au fumage d'autres denrées alimentaires.

PARK LIFE # 012 / THE SMOKEHOUSE KITCHEN-BUILDING

The Smokehouse Building has a smoking room that can also be used as a storage area for tools and equipment needed for the smoking process, set beside a freshwater river fish farm. The fish can be caught for smoking in situ, and their preparation and consumption also take place on the same site. It is possible to smoke other foodstuffs apart from fish.

PARK LIFE #012 / THE SMOKEHOUSE KITCHEN-BUILDING

Das Smokehouse Building hat ein Räucherzimmer, das auch als Lagerraum für das Werkzeug und die Ausrüstung genutzt werden kann, die für das Räucherverfahren benötigt werden. Es steht neben einer Süßwasser-Flussfischfarm. Der Fisch kann für das Räuchern vor Ort gefangen werden, seine Zubereitung und sein Verzehr finden ebenfalls am gleichen Ort statt. Neben Fisch lassen sich auch andere Nahrungsmittel räuchern.

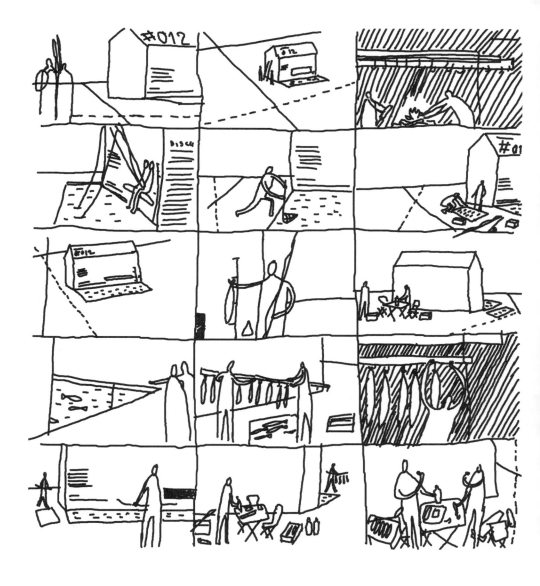

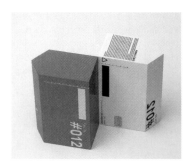

LE LECTEUR DE PHOTOS[1]

La métamorphose est depuis l'Antiquité un des motifs les plus importants de la littérature. J'incline à penser que les objets de Martí Guixé se sont métamorphosés en images.

_ MÉTAMORPHOSES IMAGINAIRES

Il me semble qu'une chauve-souris sera déconcertée par une réalité bidimensionnelle et qu'un chat suivra des yeux, médusé, les ombres mobiles projetées autour du bocal par la chorégraphie des poissons rouges.

_ LE TRAVAIL DE LA MÉTAMORPHOSE

Mon travail consiste à documenter les œuvres de Guixé par la photographie. A la différence des livres précédents, *Food design* et *1:1 Martí Guixé*, les illustrations du présent ouvrage ne sont aucunement des vues plongeantes. Dans le texte qui accompagne *Food design*, j'explique qu'une prise de vue de haut permet à la photographie de se transformer en maquette ou plan de l'objet représenté et que l'image obtenue fonctionne *effectivement* comme maquette

THE PHOTO READER[1]

Metamorphosis has been one of the major themes of literature since Antiquity. I suspect that Martí Guixé's objects have metamorphosed into pictures.

_ IMAGINED METAMORPHOSES

I imagine that a bat might be confused by the idea of two-dimensional reality and that a cat gazes with wonder at the distinct silhouettes of shadows sent up into the air by fishes in their gesticulating speech.

_ WORK ON METAMORPHOSIS

I document Guixé's work by means of photography. Unlike in his previous books *Food design* and *1:1 Martí Guixé*, the pictures in this book are not linked to top view. In the text of *Food design* I argued that, through use of top view, the picture becomes a plan of what is depicted and that the picture accordingly functions as a plan of the object.[2]

DER FOTOLESER[1]

Die Verwandlung ist seit der Antike eines der wichtigsten Motive der Literatur. Die Objekte von Martí Guixé haben sich vermutlich in Bilder verwandelt.

_ AUSGEDACHTE VERWANDLUNGEN

Ich stelle mir vor, dass eine Fledermaus durch die Idee einer zweidimensionalen Wirklichkeit verwirrt sein könnte und dass eine Katze die lauten Schattensilhouetten bestaunt, welche die Fische beim gestikulierenden Sprechen in die Luft schicken.

_ ARBEIT AN DER VERWANDLUNG

Ich dokumentiere die Arbeit von Guixé mit Fotografie. Im Unterschied zu den vorausgegangenen Büchern „Food design" und „1:1 Martí Guixé" sind die Bilder im vorliegenden Buch nicht an die Aufsicht gebunden. In „Food design" habe ich ausgeführt, dass durch die Aufsicht das Bild zum Plan des Abgebildeten wird und dass das Bild als Plan des Objekts funktioniert.[2]

ou plan de l'objet représenté[2].

Mais la maquette n'est pas le seul résultat inconditionnel d'une vue plongeante car il s'agit de trouver l'angle de vision qui embrassera la totalité de l'objet et en donnera une description complète. Dans le document photographique, l'objet est présenté au premier plan et je m'interdis de produire une image autonome. Pour m'assurer de la neutralité de la photographie, j'ai diverses stratégies à disposition:

_1 L'objet est reproduit comme un tout et peut de la sorte être intégré dans un contexte plus vaste. Si la prise de vue était partielle, l'objet ferait en premier lieu référence à lui-même.

_2 Grâce à la neutralité de l'angle de vision, le lecteur/spectateur n'est pas livré à la vision subjective du photographe; la matérialité de l'objet n'est pas mise en avant.

_3 La représentation graphique devant un arrière-plan neutre et discret, associé à un angle de vision spécifique vise à donner une impression de superficialité ou d'aplat; le symbole est ainsi plus facilement identifiable que si la

The plan is however not unconditionally bound to top view. The important factor is to find and adopt the viewpoint that describes the object comprehensively. The photographic document focuses on the object and has no desire to produce an independent image. In order to guarantee the neutrality of the photograph I adhere to various strategies:

_1 The object is depicted as a whole and can thus be placed in any larger context; as a part view it would primarily relate to itself.

_2 Because of the neutral viewpoint, the recipient does not have the photographer's subjective view foisted upon him/her or have the object's materiality prejudged.

_3 The graphic representation against a neutral, unspectacular background, combined with the specific viewpoint, aims at two-dimensionality and is thus much more like identification of symbols than linkage into a story.

_4 The space around the picture is indicated only by the light, usually coloured shadow thrown by the object;

Der Plan ist jedoch nicht bedingungslos an die Aufsicht gebunden, sondern es geht darum, den Aufnahmestandpunkt zu finden und zu beziehen, der das Objekt umfassend beschreibt. Das fotografische Dokument stellt den Gegenstand in den Vordergrund und will kein eigenmächtiges Bild produzieren. Um die Neutralität des Bildes zu gewährleisten, halte ich verschiedene Strategien ein:

_1 Der Gegenstand wird als Ganzes abgebildet und kann somit in jeden größeren Zusammenhang gestellt werden. In einer Teilansicht würde er zuerst auf sich selbst Bezug nehmen.

_2 Durch den neutralen Aufnahmestandpunkt wird dem Rezipienten nicht die subjektive Sicht des Fotografen untergeschoben und die Materialität des Gegenstandes vorbewertet.

_3 Die grafische Darstellung vor neutralem und unspektakulärem Hintergrund verbunden mit dem spezifischen Aufnahmestandpunkt ist auf Flächigkeit ausgerichtet und so der Erkennung von Symbolen viel näher als der Einbindung in eine Geschichte.

_4 Nur ein leichter, meist farbiger Schatten des Objekts verweist auf den Bildumraum. Niemals werden die Objekte

photographie donnait lieu à une intégration anecdotique dans un décor.

_4 Seule une ombre diffuse de l'objet, généralement colorée, évoque l'espace environnant. L'objet n'est jamais détaché de son contexte après coup.

La photo réalisée selon ces prémisses n'est ni photogénique ni séduisante, mais descriptive et communicative. Le photographe tient le rôle d'un reporter; rien ne l'oblige plus à obtenir la séduction photographique habituellement exigée par les commandes commerciales. La photographie est utilisée comme «système destiné à effacer l'objet». L'image photographique devient un «autre» objet et, de ce fait, le sujet même de la photographie s'efface au profit de sa reproduction.[3] Contrairement à l'imitation de la tridimensionnalité dans les reproductions traditionnelles d'objets, le nouvel objet «image» ou «photo» s'ouvre à différents niveaux sur d'autres mondes, eux-mêmes véhicules d'informations nouvelles. Le nouvel objet «photo» n'a jamais de charge affective. En revanche la photographie donne de nombreuses informations sur l'objet. Ainsi l'objet matériel s'est métamorphosé en un objet immatériel et conceptuel

objects are never repositioned freely afterwards.

The photograph produced according to the premises set out above is not photogenic and seductive, but descriptive and communicative. The photographer takes on the role of reporter and is no longer tied to the task of seduction, which is customary and decisive in the field of commercial photography. Photography is used as a system that overwrites the object. The photographic image becomes a new object, and as a result the object disappears.[3] Contrary to the emulation of three-dimensionality in ordinary pictures of objects, the new object – "picture" – opens up other information-giving worlds on different levels. These worlds are never emotionally charged. Rather, the photo provides a great deal of information about the object. The material object has thus been transformed into an immaterial, intellectual object that is consumed via reading. Reading itself becomes a form of consumption. The reading of visual information is the link to the above-mentioned plan of a picture. A plan does not necessarily have to be photogenic either.

im Nachhinein freigestellt.

Das nach diesen Prämissen hergestellte Bild ist nicht fotogen und verführerisch, sondern beschreibend und kommunikativ. Der Fotograf nimmt die Rolle eines Berichterstatters ein und ist nicht mehr an den Verführungsauftrag gebunden, der in der kommerziellen Fotografie üblich und entscheidend ist. Diese meine Fotografie der Objekte von Martí Guixé wird als System benutzt, das seine Gegenstände überschreibt.

Das fotografische Bild wird zum neuen Objekt, und das Objekt verschwindet dadurch.[3] Entgegen der Nachahmung der Dreidimensionalität in herkömmlichen Objektbildern eröffnet das neue, „kommunikative" Objekt „Bild" auf verschiedenen Ebenen andere informationsgebende Welten. Diese sind niemals emotional besetzt. Vielmehr gibt das Bild unterschiedlichste Informationen über das Objekt. So ist aus dem materiellen Objekt ein immaterielles und geistiges Objekt geworden, das lesend konsumiert wird. Das Lesen wird selbst zum Konsum. Die Lektüre der Bildinformation ist die Verbindung zum oben angeführten Plan eines Bildes. Auch ein Plan muss nicht zwingend fotogen sein.

qui se consomme à la lecture. La photographie devient elle-même nourriture spirituelle. La lecture de l'information iconographique est la relation à la maquette photographique évoquée plus haut. Un plan ou une maquette peuvent se passer de qualités photogéniques.

_ MÉTAMORPHOSE ACHEVÉE

Le consommateur traditionnel voyait naguère dans la photographie le bien de consommation qu'il allait s'approprier; le nouveau consommateur, pour sa part, consomme les informations iconographiques et pourra se passer des objets représentés. _Inga Knölke, Avril 2003

1 «Je lis les photos», dit Martí Guixé. 2 «L'idée comme maquette de contrôle et non comme représentation photographique», (Die Idee als Aufsichtsplan und nicht als Ansichtsbild»), Inga Knölke, in: *Food design, Martí Guixé*, Galeria H$_2$O Editorial, Barcelone, 2003. 3 «La photographie représente l'objet à la manière dont l'historiographie littéraire (chez Virgile, en particulier) est elle-même l'Histoire». Remarque de l'auteur.

_ METAMORPHOSIS CONCLUDED

The old, conventional consumer views the picture as the article of consumption before purchase; the new consumer will consume the information and no longer have need of the object. _Inga Knölke, April 2003

1. Martí Guixé says "I read photos". 2. "The idea as a top-view plan and not as a picture to be viewed": Inga Knölke, in Martí Guixé's *Fooddesign*, Galeria H$_2$O Editorial Barcelona 2003. 3. "Photography introduces the object, comparable to the way in which the literary writing of history (Virgil*) is history": author's note.

_ VERWANDLUNG ABGESCHLOSSEN

Der konventionelle, alte Konsument betrachtet das Bild als Konsumartikel vor dem Einkauf; der neue Konsument wird die Informationen konsumieren und die Objekte nicht mehr benötigen.

_Inga Knölke, April 2003

1 „Ich lese Fotos", sagt Marti Guixé. 2 „Die Idee als Aufsichtsplan und nicht als Ansichtsbild", Inga Knölke, in: *Food design, Martí Guixé*, Galeria H$_2$O Editorial, Barcelona 2003. 3 „Die Fotografie stellt das Objekt vor, vergleichbar mit der Art, wie die literarische Geschichtsschreibung (Vergil) Geschichte ist." Anmerkung der Autorin.

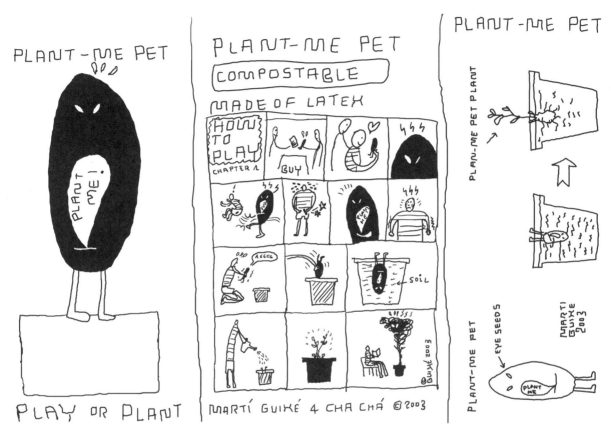

Le Plant-me Pet, dont les yeux sont des graines de légumes potagers, est inutile tant que vous ne l'avez pas fait disparaître, tant que vous ne l'avez pas enfoui dans la terre pour le faire pousser et devenir une plante comestible. C'est un petit animal qui vous oblige de choisir entre l'émotion et la fonction. _**Plant-me Pets / Produit par CHA-CHÁ, 2003**

The Plant-me Pet, with vegetable plant seeds for eyes, is useless until you make it disappear, burying it so that it might grow into an edible food plant. It is a pet that forces you to decide between emotion and function. _**Plant-me Pets / Produced by CHA-CHÁ, 2003**

Das Plant-me Pet, mit Pflanzensamen als Augen, ist nutzlos bis man es verschwinden lässt, es vergräbt, damit es zu einer essbaren Pflanze heranwachsen kann. Es ist ein Haustier, das einen zwingt, zwischen Gefühl und Funktion zu entscheiden. _**Plant-me Pets / Hergestellt von CHA-CHÁ, 2003**

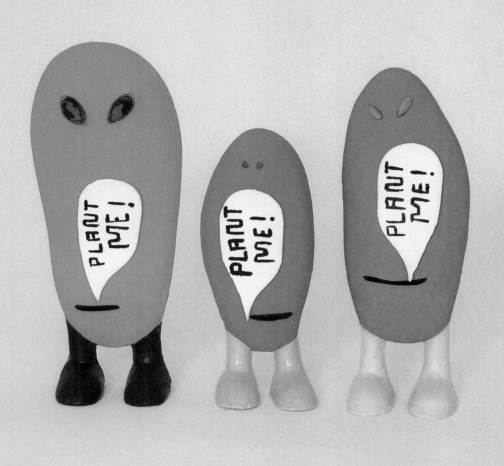

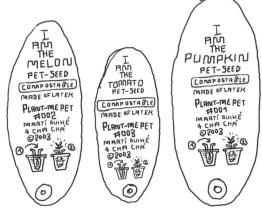

TRAVAUX PRÉSENTÉS/ LIST OF WORKS / WERKLISTE

NB: pour l'ordre alphabétique, nous avons respecté la langue telle que nous l'a transmise Martí Guixé

NB: in alphabetical order, respecting the language chosen by Martí Guixé.

Anm: Die alphabetische Ordnung entspricht der Sprache, wie sie uns Martí Guixé übermittelt hat.

REMERCIEMENTS / THANKS / DANKE

Cet ouvrage et l'exposition qui l'accompagne ont été réalisés grâce à l'engagement sans faille de Martí Guixé avec qui les échanges, entre Barcelone, Berlin, Milan et Lausanne n'ont cessé de rebondir au cours de ces derniers mois. Nos vifs remerciements s'adressent donc en tout premier lieu à Martí ainsi qu'à la photographe, Inga Knölke. Cette collaboration a été amorcée lors d'une première rencontre avec le designer catalan au moment où celui-ci fut invité par l'ECAL (École cantonale d'art de Lausanne) à un jury de travaux de diplômes en septembre 2000. Un grand merci à Pierre Keller, son Directeur, qui nous a offert cette première impulsion.

Notre vive gratitude s'adresse également aux auteurs ayant participé à la rédaction de ce livre: leurs contributions permettent d'aborder le travail de Guixé sous des angles inédits et, à chaque fois, stimulants.

Comme toujours, une telle initiative ne peut aboutir sans le soutien permanent de nombreux collaborateurs. L'équipe du mu.dac, et en particulier Claire Favre Maxwell, conservatrice, Martine Magnin, secrétaire, Michèle Bell, régisseur, Christiane Vemba, réceptionniste, Christiane Mercier, bibliothécaire, Carole Guinard, scénographe, Dominique Binda et Andreas Spitteler, techniciens, Laetitia Aeberli, stagiaire, ont relevé le défi et ont tous porté le projet jusqu'à sa réalisation concrète: je tiens à leur adresser, à chacun d'eux, mes chaleureux remerciements.

Nous sommes également ravis d'avoir pu publier cet ouvrage grâce à l'enthousiasme et la complicité des collaborateurs de la maison d'édition Birkhäuser à Bâle. Merci à Véronique Hilfiker et Robert Steiger d'avoir collaboré avec tant de professionnalisme à cette première expérience qui, nous l'espérons, se poursuivra grâce à de nouveaux partenariats. _Chantal Prod'Hom / Directrice du mu.dac / mai 2003

This book and its accompanying exhibition would not have been possible without the unwavering commitment of Martí Guixé with whom messages have been constantly bouncing back and forth between Barcelona, Berlin, Milan and Lausanne for the past few months. First of all, therefore, our warmest thanks go to Martí as well as to the photographer Inga Knölke. This close collaboration was set in motion at a first meeting with the Catalan designer when he was invited to Lausanne by the ECAL (the Lausanne Cantonal Art School) to join the jury judging diploma work in September 2000. Many thanks to director Pierre Keller who gave us this initial boost.

We are also very grateful to the authors who contributed to this book, each one enabling us to approach Guixé's work from a completely new and stimulating angle.

As always, a project like this can never be a success without the untiring support of our numerous staff members. All the mu.dac team, and especially Claire Favre Maxwell, curator, Martine Magnin, secretary, Michèle Bell, co-ordinator, Christiane Vemba, receptionist, Christiane Mercier, librarian, Carole Guinard, scenographer, Dominique Binda and Andreas Spitteler, technicians, and Laetitia Aeberli, trainee, took up the challenge and carried the project through right up to its final presentation: my warmest thanks to every one of them. We are also delighted to have been encouraged in publishing this work by the enthusiasm and complicity of all those at Birkhäuser, the publishing house in Basel. We are most grateful to Véronique Hilfiker and Robert Steiger for having shown such professionalism while working on this first experience which we hope will lead to many others thanks to new partnerships. _Chantal Prod'Hom / Director of the mu.dac / May 2003

Dieses Buch und die begleitende Ausstellung sind dem unerschütterlichen Engagement Martí Guixés zu verdanken, mit dem in den vergangenen Monaten der Austausch zwischen Barcelona, Berlin, Mailand und Lausanne immer wieder in Gang gekommen ist. Unser besonderer Dank geht daher in erster Linie an Martí sowie an die Fotografin Inga Knölke. Die Zusammenarbeit begann während einer ersten Begegnung mit dem katalanischen Designer, als er im September 2000 von der ECAL (École cantonale d'art de Lausanne) zu einer Jury für Diplomarbeiten eingeladen war. Ein großes Dankeschön gilt Pierre Keller, ihrem Direktor, der uns den ersten Anstoß gegeben hat.

Auch den Autoren, die sich an der Redaktion dieses Buches beteiligt haben, schulden wir tiefen Dank: Ihre Beiträge gestatten es, die Arbeit Guixés aus ganz neuen und jedes Mal anregenden Blickwinkeln zu sehen.

Wie immer kann eine solche Initiative nicht ohne die anhaltende Unterstützung von vielen Mitarbeitern erfolgreich abgeschlossen werden. Das Team des mu.dac und insbesondere Claire Favre Maxwell (Wissenschaftliche Leitung), Martine Magnin (Sekretariat), Michèle Bell (Verwaltung), Christiane Vemba (Empfang), Christiane Mercier (Bibliothek), Carole Guinard (Kulissenmalerei), Dominique Binda und Andreas Spitteler (Technik) nahmen die Herausforderung an, und jeder von ihnen hat das Projekt bis zu seiner konkreten Realisation geführt. Ich lege Wert darauf, ihnen allen meinen herzlichen Dank auszusprechen. Wir freuen uns auch, dass wir dieses Buch dank des Enthusiasmus und der Unterstützung durch die Mitarbeiter des Birkhäuser Verlags in Basel veröffentlichen konnten. Dank an Véronique Hilfiker und Robert Steiger, die mit so viel Professionalität an dieser ersten Erfahrung mitgewirkt haben, die sich, wie wir hoffen, in weiteren gemeinsamen Projekten fortsetzen wird. _Chantal Prod'Hom / Direktorin des mu.dac / Mai 2003

Ce livre paraît à l'occasion de l'exposition du même nom; ouverture en juin 2003 à Lausanne
This book appears on the occasion of the exhibition of the same name, starting June 2003 in Lausanne
Dieses Buch ist anlässlich der Ausstellung gleichen Titels erschienen, Eröffnung Juni 2003, Lausanne:

Martí Guixé
Libre de contexte / Context-free / Kontext-frei
26.06.–28.09.2003
Exposition et catalogue conçus par / Concept of the exhibition and the catalogue / Konzept der Ausstellung und des Katalogs
Chantal Prod'Hom, directrice du mu.dac
et / and / und Martí Guixé
Avec la collaboration de / With the collaboration of / In Zusammenarbeit mit
Claire Favre Maxwell, conservatrice du mu.dac
Assistés de / Supported by / Unterstützt von
Martine Magnin, Michèle Bell, Carole Guinard, Christiane Mercier, Christiane Vemba, Gabrielle Guth,
Dominique Binda, Andreas Spitteler, Pedro Vemba, Jean-Pierre Broyon et / and / und Laetitia Aeberli.

Kitchen-Buildings:
Conseils / Advice / Beratung: Arq. Carles Muro
Assistante pour les maquettes / Models assistant / Assistenz Modelle: Ariadna Fàbregas

Assistante graphique des Daylight Shop Cards / Design assistant for Daylight Shop Cards / Assistenz Gtafik der Daylight Shop Cards: Anna Llàcer
Assistance pour l'architecture / Architectural assistance / Assistenz Architektur: MPtree Project: Edu
UdCDUC Production: Edu, Oriol Caba
Camper Projects / Merci à / Thanks to / Dank an: Michel Campioni, Miguel Muñoz Padellano, Janina Bea, Pablo Martín (Gràfica)
Food Bank, Plant Emulator Tape, multiples: courtesy Galeria Palma XII, Vilafranca del Penedès, Barcelona

mu.dac / Musée de design et d'arts appliqués contemporains
Place de la Cathédrale 6 CH – 1005 Lausanne
T.: + 41 21 315 25 30 F.: + 41 21 315 25 39
mu.dac@lausanne.ch www.lausanne.ch/mudac

Traductions / Translations / Übersetzungen:
Anglais / allemand – français: Solange Schnall, Paris / F
French / German – English: Jenny Marsh, Poole / GB
Französisch / Englisch – Deutsch: Joanna Zajac-Wernicke, Unnau / D
Spanish – English for texts Martí Guixé: Jeffrey Swartz, Barcelona / E

Photographies / Photographs / Fotos:
Inga Knölke, Berlin
Graphisme / Graphic design / Grafik:
Flavia Cocchi, Lausanne
Photolitho:
Images 3, Lausanne

A CIP catalogue record for this book is available from the Library of Congress, Washington D.C., USA.

Bibliographic information published by Die Deutsche Bibliothek
Die Deutsche Bibliothek lists this publication in the Deutsche Nationalbibliografie; detailed bibliographic data is available in the internet at http://dnb.ddb.de.

Printed on acid-free paper produced from chlorine-free pulp. TCF ∞
Printed in Germany
ISBN 3-7643-2422-8

987654321

http://www.lausanne.ch/mudac
http://www.birkhauser.ch